C000218118

ICONS

Pussycats

Gilles Néret

TASCHEN

KÖLN LONDON LOS ANGELES MADRID PARIS TOKYO

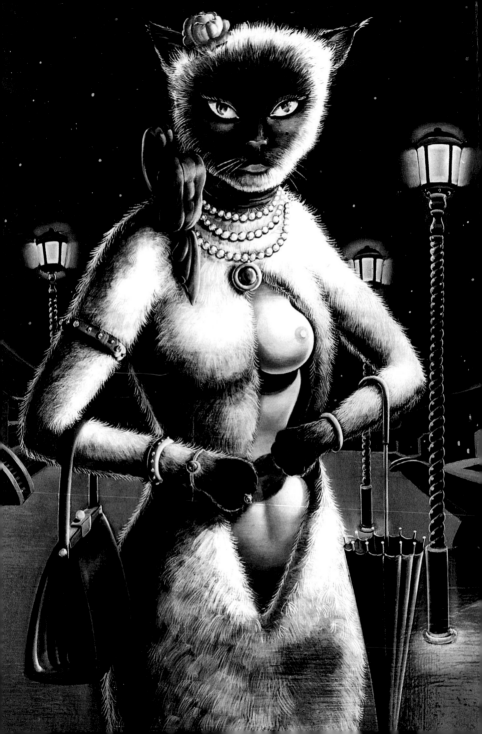

Contents | Inhalt | Sommaire

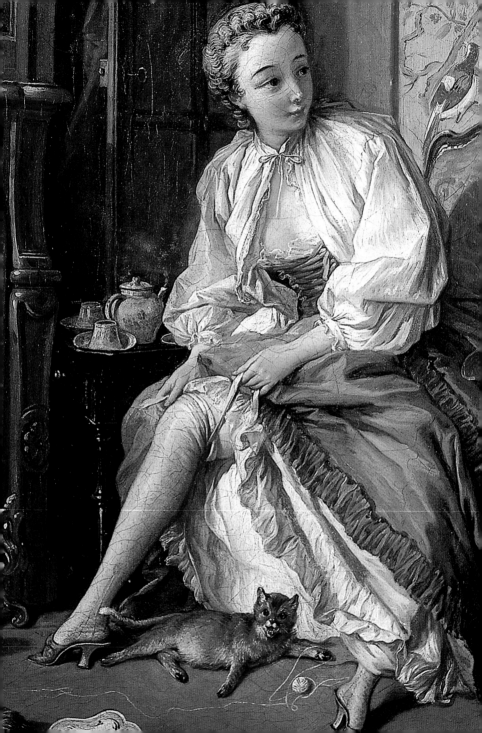

A Cat Licking Herself ...

»Painting is private life«, Degas used to say. »It's the human beast going about its business, the way a cat licks herself.« Artists from Rembrandt to Picasso, from Fragonard to Ingres, from Klimt and Schiele to Grosz, Dix and Schad, or Bellmer and Wesselmann, have all been bowled over by one particular form of simplicity and naturalness, the like of which they found nowhere else: watching women go about their secret, private business, spying on them through the keyhole, and portraying the fascination of women's self absorption, as they explore their own bodies like undiscovered worlds, looking only to themselves at last.

According to sexologists, and disciples of the good Doctor Freud, one of the strongest components of the male libido is the inexhaustible desire to return to the mother, and hence lose oneself in the sea ... In accepting men's visual homage, women demonstrate a generous abandon. They offer up to the gaze the thing that they have been trained to guard most jealously, keep out of sight and protect from prying eyes. Such women break the strongest taboo in our culture, by showing, as the popular expression would have it, »everything«.

Since eternal time, artists have hungered for something more than a simple feminine nude, and have always been tempted to go further, wanting to see it all and show it too ... for not seeing is a form of torture, while seeing brings relief. Henry Miller, in *Tropic of Capricorn*, confesses that lying beneath a woman in a park one day, seeing »everything« from his particular vantage point, he felt so at peace with the world that he fell into a deep sleep.

There is no doubt that for women themselves, but also for men in love, and for enthusiastic artists, the female sex organs and their different uses constitute the most endlessly astonishing of all mysteries. Courbet clearly thought so, and showed as much with *The Origin of the World*; Rodin called it *The Eternal Tunnel*, and he was the first to split it open, with *Iris, Messenger of the Gods*, who straddled time and revealed the treasure that had so long remained hidden. In Antiquity, even Venus herself was not allowed the privilege of such explicit exposure. For the ancient Greeks thought of a woman's sex organs as a forbidden grotto that led down to Hell, considering death to be as »dark and hollow as a woman.« The origin, perhaps, of their appeal, of a fundamental misunderstanding, and of man's insatiable curiosity: men have never forgiven women for being different and yet the

François Boucher *The Toilet* (detail), 1742. Madrid, Museo Thyssen-Bornemisza

same, and above all for possessing an autonomous subjectivity totally independent of physical strength. Women know that very well, and never hesitate to use the privilege to their advantage. As Simone de Beauvoir, the muse of philosopher Jean-Paul Sartre, put it in *The Second Sex*, »A woman's sex is like the gentle palpitation of a shellfish: it waits like a carnivorous plant, in the boggy marsh where insects and children lose their way; it is suction, a wet leech, sticky and treacherous like pitch and glue …«

Trained to be provocative, to wake men from their apathy and ensure the survival of the species, women are natural exhibitionists. *Haute couture* is proof enough of that. As soon as one designer reveals a part of the body that was supposed to be kept secret, women leap upon it with enthusiasm. »The Eternal Feminine makes cretins of men,« as Salvador Dali liked to say. Down the centuries, in the lowered eyes or the calmly provocative stare of those women in Medieval manuscripts and in the vulvular landscapes and other erotic mythologies of the modern era, an ecstatic, almost osmotic exchange between artist and model is at work, a master-slave dialectic where who occupies which position is far from certain. A complicity is discernible between the two, which occasionally takes on the appearance of a sort of *amour fou*. Isadora Duncan, who posed for him, spoke of how Rodin »sculpted your flesh before turning his burning grip to the clay.« The sculptor Henry Moore claimed that »on a mountainside, the most interesting element by far is not the mountain, but the caves to be found there,« adding »the first time I made a hole in stone, it was a revelation.« Let's remove the veil from our eyes – when he said a hole, he meant the sex of the Earth, the orifices of Woman.

Poets have traditionally compared it to a flower (analogies with other fauna are all too clear), a bird, or marine life in general. The prey that these hunters chase is the bird of Venus: sculpted shells, brown seaweed and bivalve molluscs opening to reveal the delicate shades of flesh tinged with tropical coral or the purple of Sidon. »The Whistling Bird«, Brantôme called it, »whose noisy waterfall makes for a distant, shameless tinkling,« – making men happy. For the artist's interest rarely stops at the cave: he can be equally moved by the streams that flow out from it. Henry Miller noted elsewhere that »when men burn with a passion to know things, they want to know it all – they even want to see how women piss.« In 1631, Rembrandt, deeply in love with his wife, sold the hypocritical burghers of Amsterdam an engraving of his wife, skirts raised and legs apart, in full stream. In 1965, Picasso in his turn painted the homage that is his *Pissing Woman*, two metres high and now the pride and joy of the Picasso Museum in Paris.

Salvador Dalí *La Chatte de Bouguereau* or *Monument of the Child-Woman*, 1977

Victor Marais Milton *Young Cats*. Painting exhibited at the »Salon de Paris«, c. 1900

Eine Katze, die sich leckt…

»Die Malerei behandelt das Privatleben«, sagte Degas, »sie ist das Tier im Menschen, das sich mit sich selbst beschäftigt, eine Katze, die sich leckt.« Alle Künstler, von Rembrandt bis Bonnard und Picasso, von Fragonard bis Ingres, von Klimt und Schiele bis Grosz, Dix und Schad oder von Bellmer bis Wesselmann, waren überwältigt von einer Natürlichkeit, einer Einfachheit, die sie sonst nirgendwo entdecken konnten: der Frau, die bei ihrer privatesten und intimsten Beschäftigung überrascht, beobachtet wird wie durch ein Schlüsselloch. Aus dieser Position konnten sie den Eindruck erwecken, dass dieser Körper ganz und gar damit beschäftigt war, sich selbst zu entdecken, sich zu erforschen wie einen unbekannten Kontinent, sich einzig und allein mit sich selbst zu beschäftigen. Darf man den Sexologen, den Schülern Sigmund Freuds, glauben, so ist der Mensch von einem der stärksten Triebe, die seine Libido bestimmen, angetrieben: dem unauslöschlichen Begehren, in den Mutterleib, ins Meer zurückzukehren… Akzeptiert die Frau die visuelle Verehrung des Mannes, gibt sie sich großzügig den Blicken hin. Sie bietet dem Auge all das dar, was sie raffiniert zu verbergen gelernt hat, was sie niemals herzeigt und unablässig vor unerwünschten Betrachtern schützt. Sie bricht das in unseren Sitten am tiefsten verankerte Tabu und »zeigt alles«, wie man volkstümlich so sagt. Gerade das hat die Künstler bewogen, über die reine Darstellung der weiblichen Nacktheit hinaus noch weiter zu gehen und alles sehen und alles zeigen zu wollen. Denn nichts zu sehen ist gleichbedeutend mit Qual, während Sehen Befriedigung gibt. Henry Miller gesteht in seinem Buch »Wendekreis des Krebses«, dass er in einem öffentlichen Park einmal unterhalb einer Frau gelegen und »alles gesehen« habe. Durch diesen Anblick sei er so befriedigt gewesen, dass er einschlief. Eins ist sicher, zu allererst für die Frau selbst, aber auch für den verliebten oder liebeshungrigen Mann, den verzückten Künstler, ist das weibliche Geschlecht mit seinen verschiedenen Funktionen sowie den verschiedenen Arten, sich seiner zu bedienen, das erstaunlichste, das aufregendste aller Mysterien. Für ihn ist es zugleich *Der Ursprung der Welt*, wie Courbet ihn gemalt hat, oder *Der ewige Tunnel*, wie Rodin es nannte, der es nach zweitausend Jahren als erster wagte, die verbotene göttliche Spalte den Blicken zu öffnen, als er seine Skulptur *Iris, die Götterbotin* schuf. Eine Spalte, auf die nicht einmal Venus in der Antike einen Anspruch hatte – das war doch wohl der Gipfel. Denn das Geschlecht der Frau ist auch für den Mann jene verhängnisvolle Höhle, die direkt in die Hölle führt, wie die alten Griechen meinten, für die der Tod »unergründlich und dunkel wie die Frau« war. Vielleicht resultiert

daraus diese Verwirrung, dieses grundlegende Missverständnis, aber auch diese enorme Neugier: Der Mann hat der Frau niemals verziehen, dass sie anders ist als er, wo sie ihm doch gleichzeitig so ähnlich ist, und ebenso wenig, dass sie eine autonome Subjektivität besitzt, trotz ihrer geringeren Körperkraft. Die Frau weiß das sehr wohl und hat keine Skrupel, dieses Privileg zu ihrem Vorteil zu nutzen. Simone de Beauvoir, die Lebensgefährtin und Muse des Philosophen Jean-Paul Sartre, hat in ihrem Buch »Das zweite Geschlecht« geschrieben: »Die weibliche Erregung ist das weiche Zucken einer Muschel; sie lauert wie eine Fleisch fressende Pflanze, sie ist wie der Sumpf, in dem Insekten und Kinder versinken; sie ist Saugnapf und Schröpfkopf, sie ist Pech und Klebstoff…« Da die Frau darauf konditioniert ist, den Mann zu locken, ihn aus seiner Apathie zu wecken dadurch den Fortbestand des Menschengeschlechts zu sichern, ist sie von Natur aus Exhibitionistin. Die Kollektionen der Modeschöpfer sind dafür der beste Beweis: Sobald ihre Kreationen einen bisher geheim gehaltenen Teil des weiblichen Körpers besonders stark enthüllen, fallen die Frauen begeistert darüber her. »Das ewig Weibliche macht den Mann zum Vollidioten«, so die Worte von Salvador Dalí.

Der Bildhauer Henry Moore sagte einmal, dass »im Gebirge das Interessanteste nicht die Berge sind, sondern die Höhlen, die man darin findet.« Er fügte hinzu: »Das erste in einen Stein gehauene Loch war eine Offenbarung für mich.« Verhüllen wir nicht das Antlitz, mit Loch meinte er das Geschlecht der Erde, die Öffnung der Frau. Das, was die Dichter üblicherweise mit einer Blume vergleichen und dessen Analogie mit der Fauna im Allgemeinen, dem Vogel oder dem Meerestier im Besonderen, unübersehbar ist. Der Venusvogel zum Beispiel, dem die Jäger nachstellen; fein gemusterte Muscheln, braune Algen, zweischalige Muscheln, die sich ganz nach Belieben des Künstlers öffnen und ein zartes Fleisch preisgeben, in tropischen Korallenfarben oder in Sidonpurpur getönt. »Der Singvogel mit seinen lautstarken Tonkaskaden«, sagte bereits Brantôme, »lässt sich in weiter Entfernung als ein unverschämtes Gezwitscher vernehmen«, das den Mann beglückt. Denn der Künstler interessiert sich nicht nur für die Höhlen, sondern auch die Sturzbäche, die daraus hervorsprudeln, können ihn begeistern. Henry Miller schrieb weiter: »Wenn ein Mann vor Leidenschaft brennt, will er die Dinge sehen. Er will alles sehen, auch wie sie Pipi machen.« 1631 verkaufte Rembrandt, der sehr verliebt in seine Frau war, den scheinheiligen Bürgern von Amsterdam einen Stich, auf dem die Geliebte mit gerafften Röcken und breit auseinander gestellten Beinen zu sehen ist, wie sie gerade pinkelt. 1965 malte Picasso als Hommage an den großen Vorläufer seinerseits eine *Pinkelnde Frau*, ein zwei Meter hohes Werk, das heute eines der Prunkstücke des Musée Picasso in Paris darstellt.

Victor Marais Milton *Lucy's Pussy*. Painting exhibited at the »Salon de Paris«, c. 1900 11

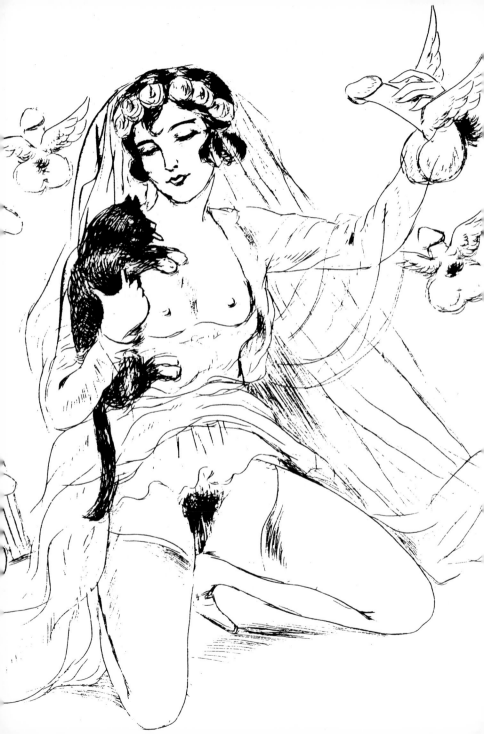

Une Chatte qui se lèche …

«La peinture, c'est de la vie privée», disait Degas, «c'est la bête humaine qui s'occupe d'elle-même, une chatte qui se lèche» … Tous les artistes, de Rembrandt à Picasso, de Fragonard à Ingres, de Klimt et Schiele à Grosz, Dix et Schad, ou de Bellmer à Wesselmann, ont semblé émerveillés par un naturel, une simplicité qu'ils n'avaient découverts nulle part ailleurs : observer, surprendre la femme dans ses occupations privées, secrètes, comme à travers un trou de serrure, ce qui leur permettait enfin de rendre cette impression d'un corps tout affairé à se découvrir avec curiosité, à s'explorer comme un monde inconnu, à s'occuper uniquement de soi-même. Selon les sexologues, disciples du bon docteur Freud, l'homme est porté par une des plus fortes pulsions charpentant sa libido : l'aspiration inextinguible à retourner dans sa mère, dans la mer … En acceptant l'hommage visuel de l'homme, la femme témoigne d'un généreux abandon. Elle offre au regard ce qu'elle a été dressée à cacher farouchement, à ne jamais laisser entrevoir, à protéger sans cesse. Elle brave le tabou le plus ancré dans nos mœurs, selon l'expression populaire : «Elle montre tout.» C'est ce qui fait que les artistes, au-delà de la représentation du simple nu féminin, aient été tentés d'aller plus loin en voulant tout voir et tout montrer … Car ne pas voir est synonyme de tourment, tandis que voir donne la paix. Henry Miller, dans «Tropique du Cancer», confie que, couché en contrebas d'une femme dans un jardin public et «voyant tout», il fut si comblé de paix par cette vue qu'il s'endormit. Nul doute, d'abord pour la femme elle-même, mais aussi pour l'homme amoureux, pour l'artiste enthousiaste, le sexe féminin et ses divers usages, ainsi que les diverses façons de s'en servir, est bien le plus étonnant, le plus excitant des mystères. N'est-il pas pour lui à la fois *L'Origine du monde* peint par Courbet, ou *Le Tunnel éternel*, ainsi que le dénommait Rodin qui osa rouvrir, après deux mille ans, la suprême fente proscrite en sculptant son *Iris, messagère des Dieux*, qui enjambe le temps en dévoilant son trésor jusque-là caché. Fente à laquelle Vénus elle-même n'avait pas droit dans l'Antiquité, ce qui était un comble. Car le sexe de la femme est aussi pour l'homme cette grotte maléfique qui mène tout droit aux Enfers, selon les Grecs anciens, pour qui la Mort était «creuse et obscure comme la femme». De là, peut-être, ce trouble, ce malentendu fondamental et aussi cette énorme curiosité : le mâle n'a jamais pardonné à la femme ni d'être différente de lui tout en lui ressemblant, ni, surtout, de posséder une subjectivité autonome malgré sa moindre force physique. La femme le sait bien et n'hésite pas à se servir à son avantage de ce privilège. Et Simone de Beauvoir,

l'égérie du philosophe Jean-Paul Sartre, a pu écrire dans son ouvrage «Le Deuxième Sexe» : «Le rut féminin, c'est la molle palpitation d'un coquillage; elle guette comme la plante carnivore, le marécage où insectes et enfants s'enlisent; elle est succion, ventouse humeuse, elle est poix et glue ...» Conditionnée pour provoquer l'homme, le réveiller de son apathie et assurer ainsi la pérennité de l'espèce, la femme, par nature, est exhibitionniste. Les collections des couturiers le montrent bien : dès que leurs créations dévoilent outrageusement une partie supposée secrète de leurs corps, les femmes s'en emparent avec enthousiasme.

«L'éternel féminin rend l'homme semblable à un crétin», aimait à dire Salvador Dalí. A travers les siècles on constate que la position, le regard baissé ou calmement provocateur des créatures que décrivent aussi bien les enluminures du Moyen-Age que les paysages vulvaires et autres mythologies érotiques de l'âge moderne, font deviner qu'entre l'artiste et le modèle s'établit comme une sorte d'osmose, d'extase, d'échange maître-esclave dont on ne sait qui est l'esclave et qui le maître. Une complicité s'établit entre les deux partenaires, qui peut prendre l'aspect d'un amour fou. Isadora Duncan, qui posa pour lui, raconte comment Rodin lui «sculptait la chair avant de reporter ses doigts brûlants sur la glaise». Le sculpteur Henry Moore prétendait que «dans une montagne, le plus intéressant, ce n'est pas la montagne, ce sont les cavernes qu'on peut y trouver». Il ajoutait : «Le premier trou creusé dans une pierre fut pour moi une révélation.» Ne nous voilons pas la face, par trou il entendait le sexe de la terre, les orifices de la femme. Qu'il s'agisse de ce que les poètes comparent traditionnellement à une fleur et dont l'analogie est évidente avec la faune en général, l'oiseau, ou l'animal marin en particulier. Oiseau de Vénus, donc, que les chasseurs pourchassent. Coquillages ciselés, algues brunes, coquilles de bivalves qui s'ouvrent au gré de l'artiste sur des chairs délicates que teintent le corail des tropiques ou la pourpre de Sidon. Voire «oiseau siffleur», selon Brantôme, «dont la cascade bruissante fait entendre à distance l'effronté gazouillis» qui rend l'homme heureux. Car l'artiste ne s'intéresse pas qu'aux cavernes, il peut aussi s'extasier devant les cascades qui en jaillissent. Henry Miller note encore : «Un homme, quand il brûle de passion veut voir les choses; il veut tout voir et même comment elles font pipi.» En 1631, Rembrandt, amoureux de sa femme, vendait aux bourgeois hypocrites d'Amsterdam, une gravure montrant celle-ci, les jupes relevées, les cuisses écartées, en train de pisser. En 1965, Picasso lui rendit hommage en peignant à son tour une *Pisseuse* de deux mètres de haut qui fait aujourd'hui l'orgueil du musée Picasso, à Paris.

Gilbert Garmon *A Pussycat Looking at Two Other Pussycats*

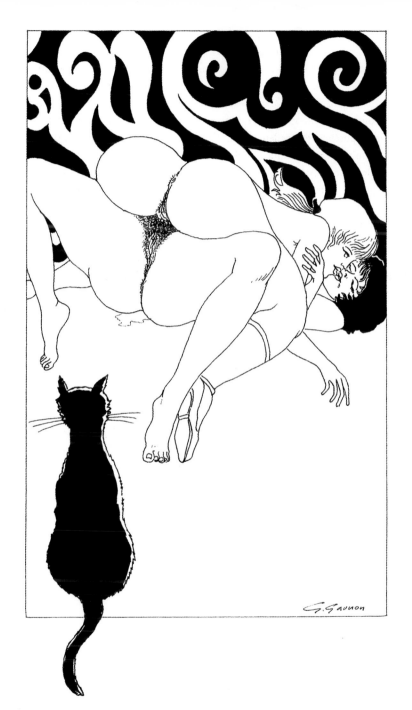

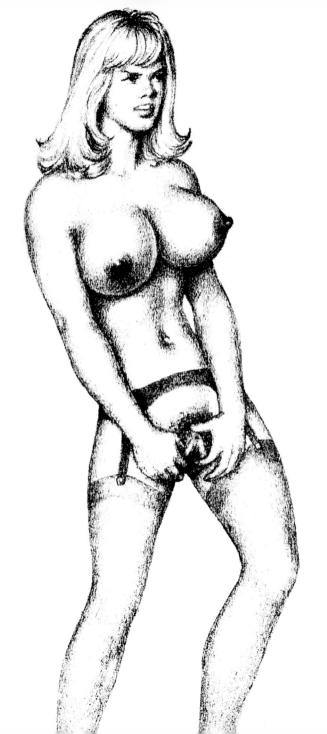

Discovery

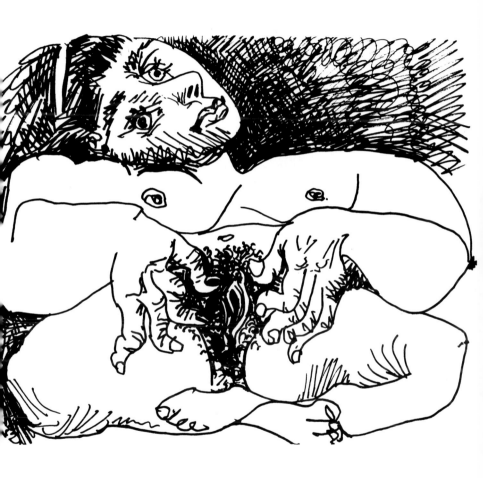

▲ **Pablo Picasso** Drawing, dated 20.8.71 III
◄ **Tom of Finland** Cover illustration for *Kake 16* (detail), 1975
►► From left to right: 1 – Babylon, *The Triangle of a Concubine*, Terra-cotta, 3000 BC,
2– Egypt, *Woman with Triangle*, 1st millenium BC; 3– Teheran, *The Luxurious Triangle*,
3rd millenium BC; 4– Sumer, *The Woman with Triangles*, 4th millenium BC

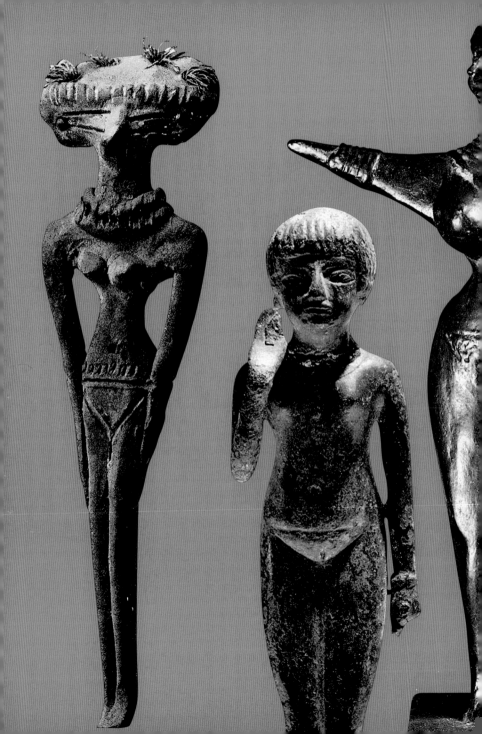

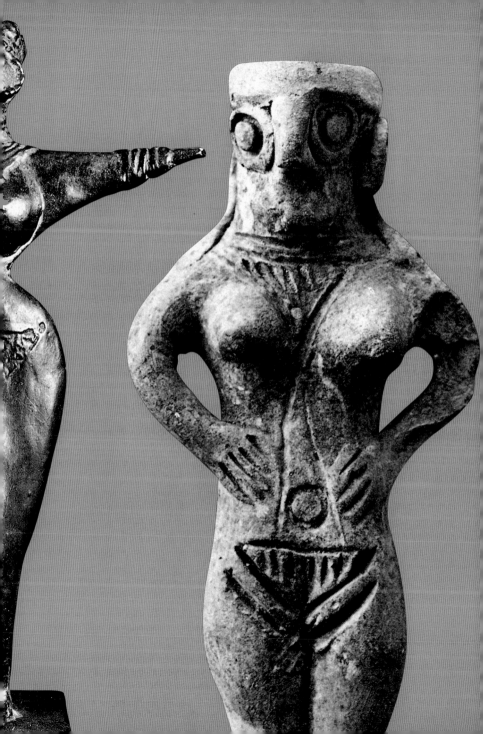

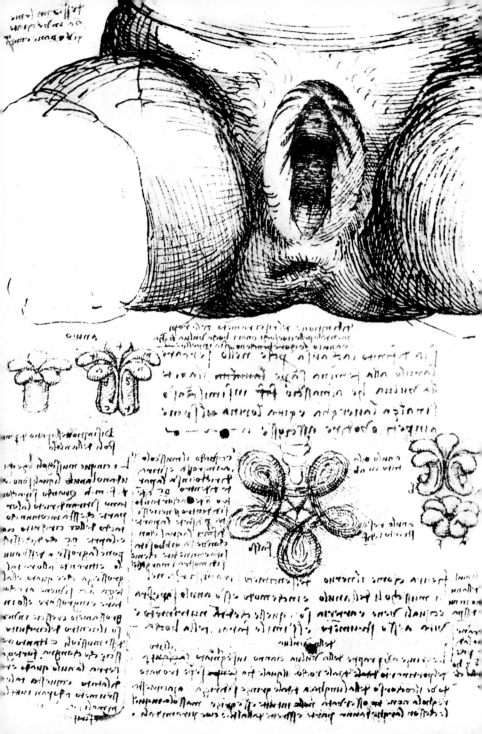

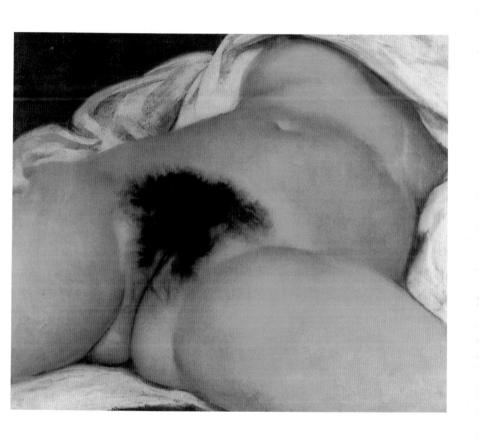

▲ Gustave Courbet *The Origin of the World,* 1866. Paris, Private collection
◄ Leonardo da Vinci *Vulva. Studies of the Mechanics of the Muscles of Body Orifices,* c. 1508/09.
Windsor Castle, Royal Library

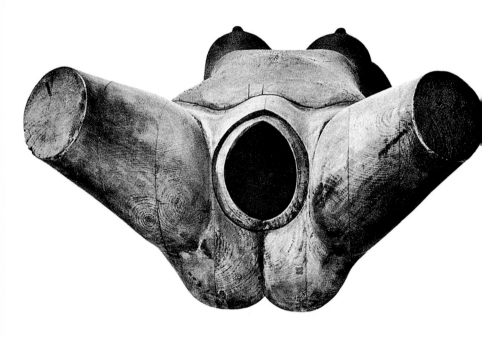

The Open Woman. Model for obstetric study. Wood, late 18th c.

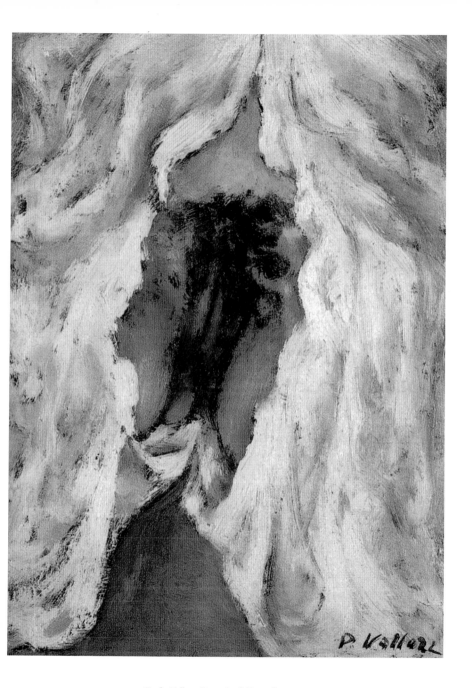

Paolo Vallorz *Portrait of Alexandra*, 1970

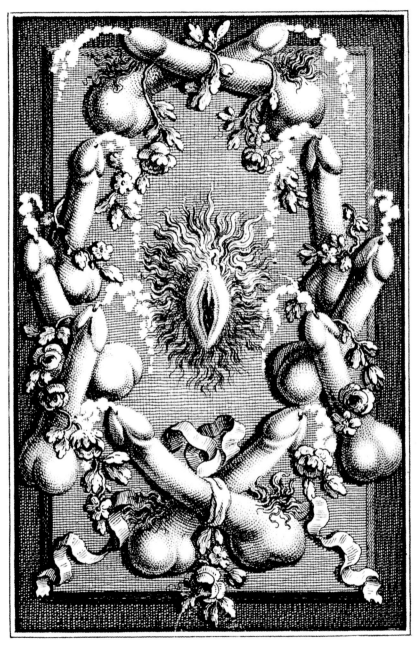

Antoine Borel, engraved by **François Roland Elluin** *The French Aretino.*
Illustrated in the style of Agostino Carracci. Published in London, 1787

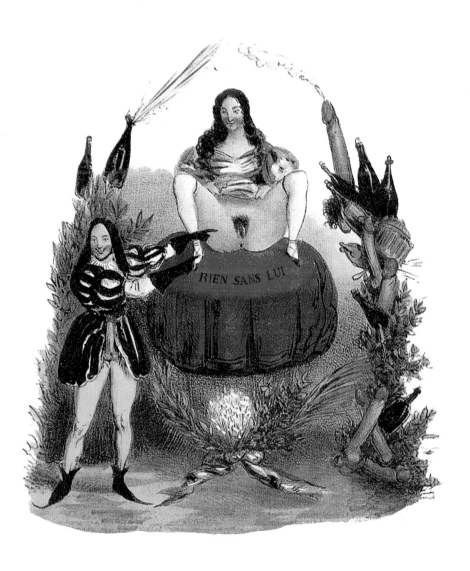

▲ **Anonymous** *Without it nothing.* Lithograph from the Romantic period
▶▶ *Vivant de Non: La Courtisane*

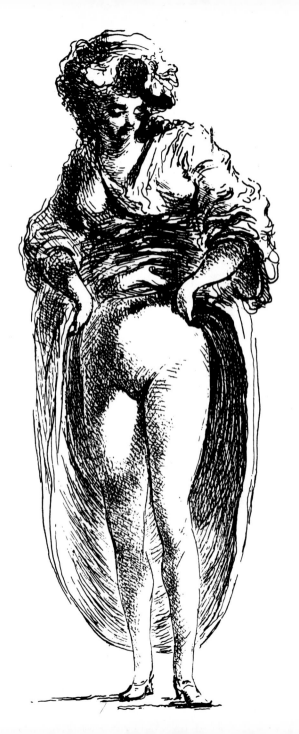

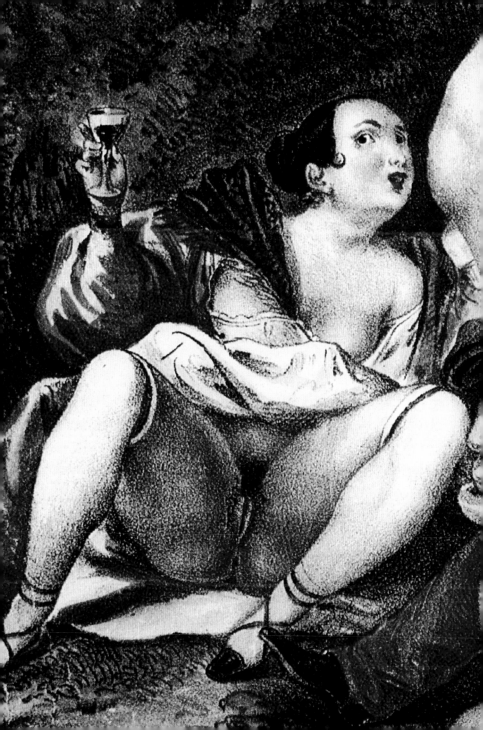

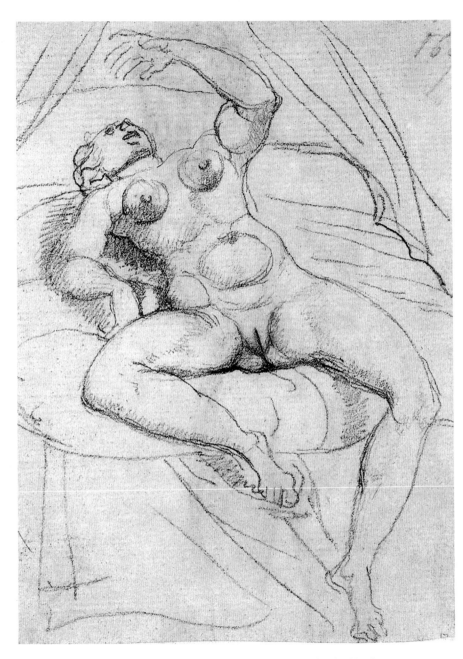

▴ **Jean-Auguste-Dominique Ingres** *Naked Woman on a Bed*. From his sketchbook, 1800–1806

◂◂ **Anonymous** *Romantic orgy* (detail). Lithograph from the Romantic period

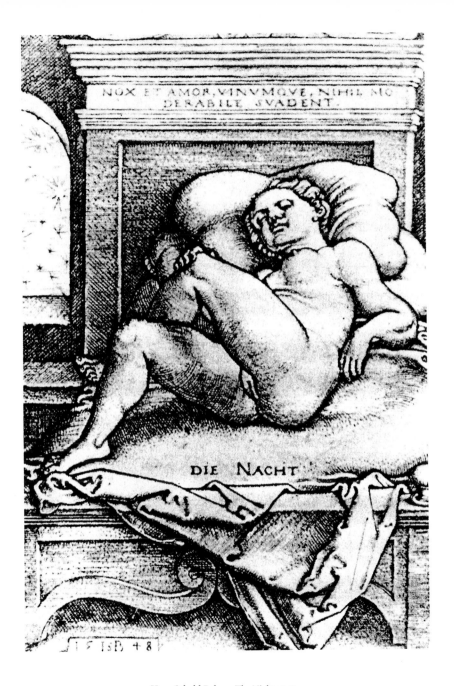

NOX ET AMOR, VINVMQVE, NIHIL MO
DERABILE SVADENT.

DIE NACHT

Hans Sebald Beham *The Night*, 1548

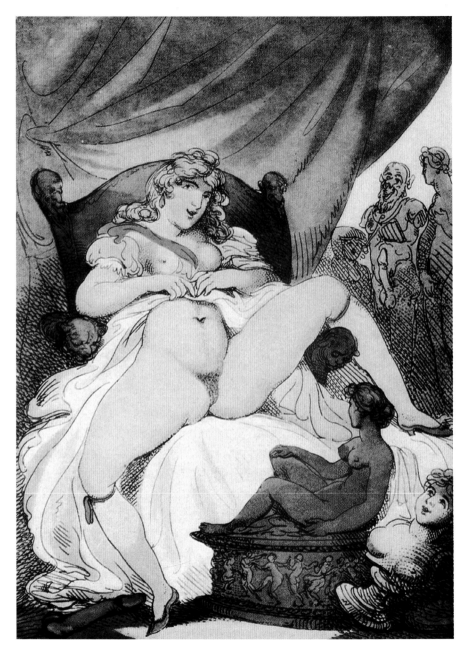

Thomas Rowlandson *Solitary diversion.*
Sequence of caricatures of the sexual practice of the English aristocracy, 1808–1817

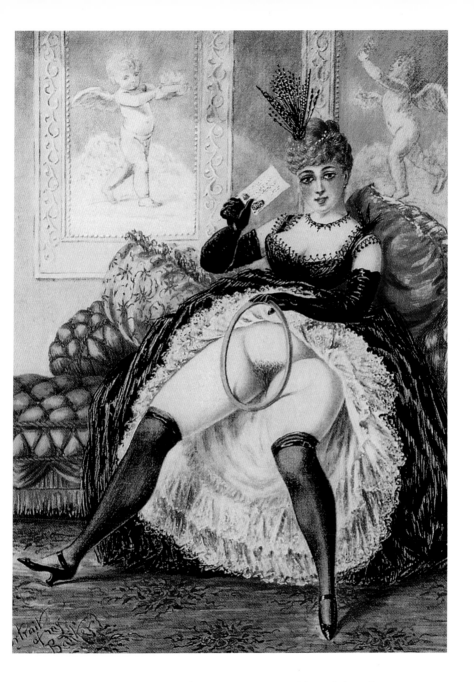

Anonymous *The Secret Life of the Bourgeoisie.* Victorian lithograph, late 18th c. 31

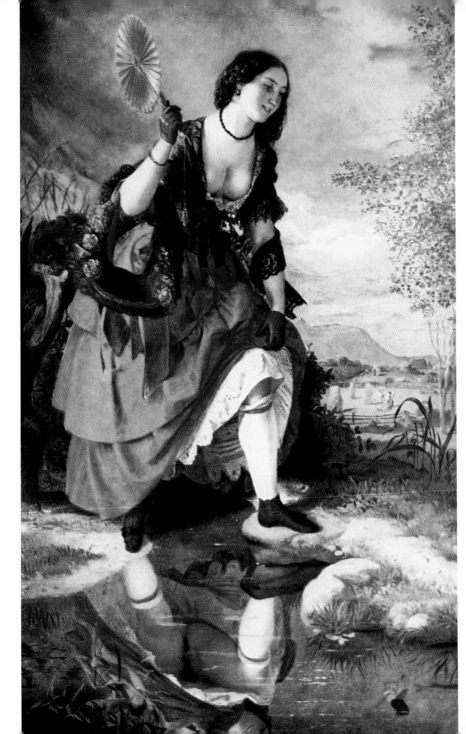

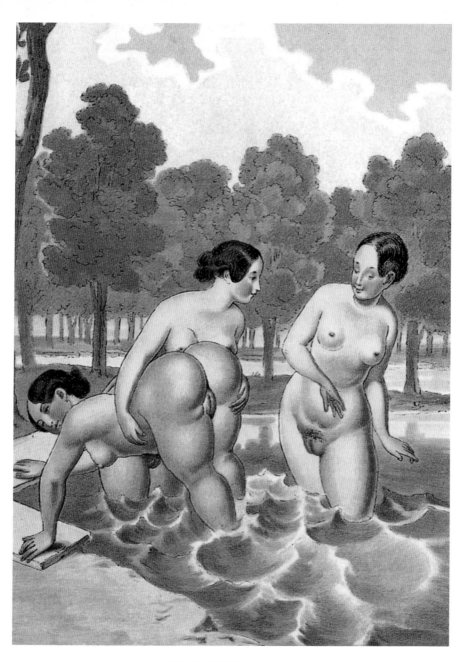

▲ Peter Fendi *Erotic Scene*, c. 1835
◄ Franz Xaver Winterhalter *Lola Montez*, 1840. Private collection

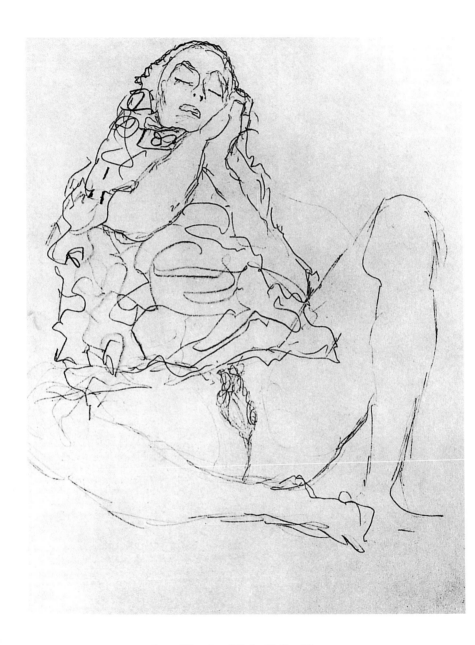

Gustav Klimt *Seated Nude with Closed Eyes,* 1913

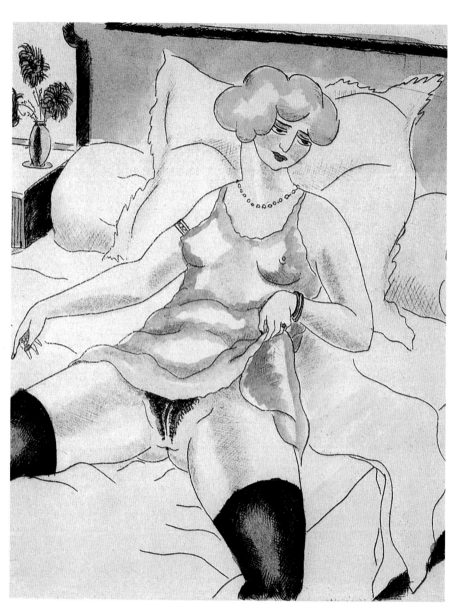

Mon lit cri' par-ci, mon lit craqu' par-là. Illustration for *Les Chansons Erotiques* by
Pierre-Jean de Béranger, French Restoration, c. 1825

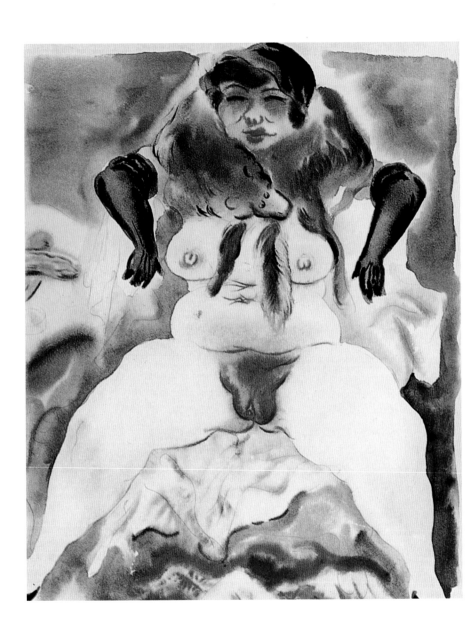

George Grosz From a series of watercolours and drawings with social implications, 1920–1930s

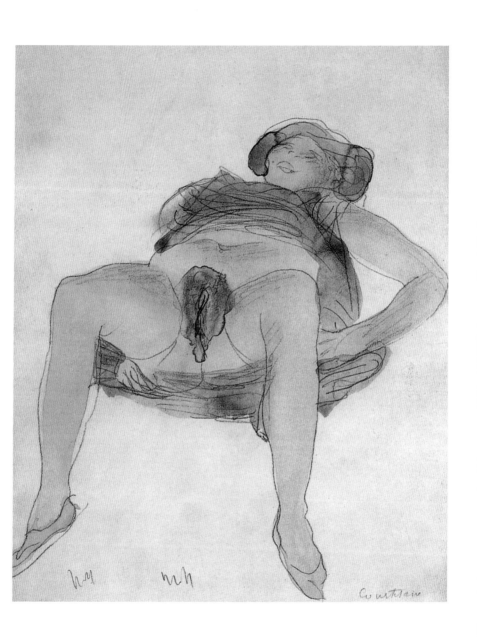

Auguste Rodin *Courtesan,* c. 1900

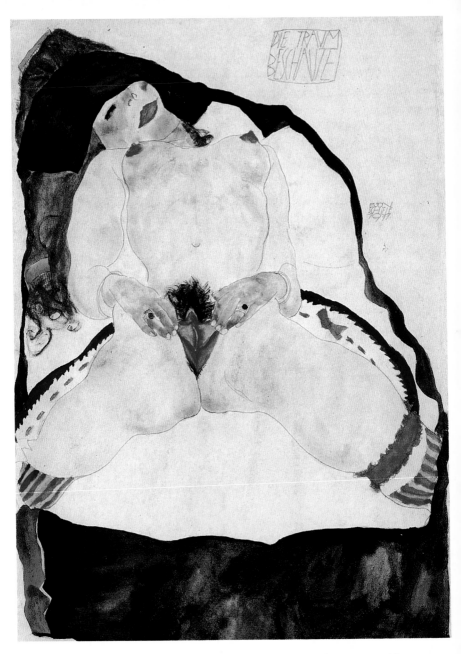

▲ **Egon Schiele** *Observed in a Dream*, 1911. New York, The Metropolitan Museum of Art

▸ **Egon Schiele** *Reclining Girl in Dark Blue Dress*, 1910

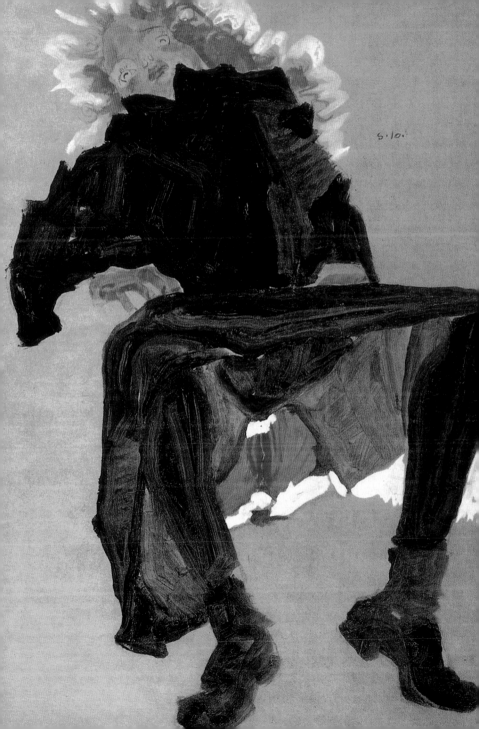

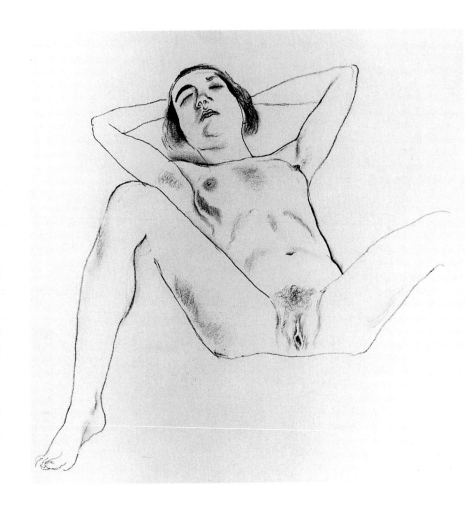

▲ George Grosz *Resting Woman*, c. 1920
► George Grosz *Young Woman*, 1921

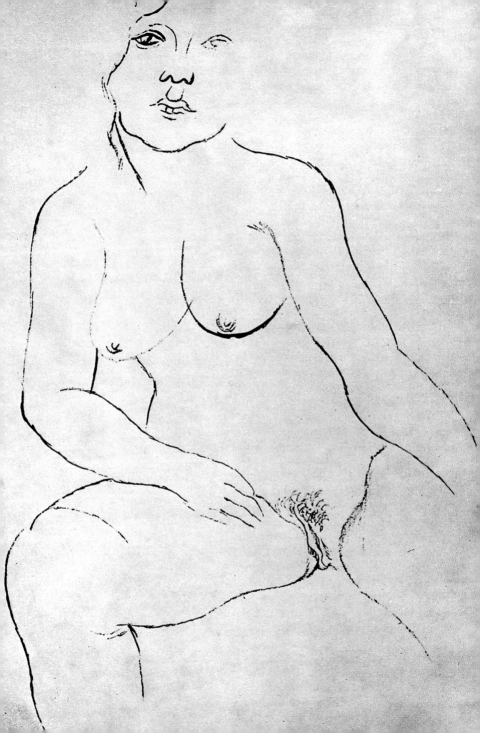

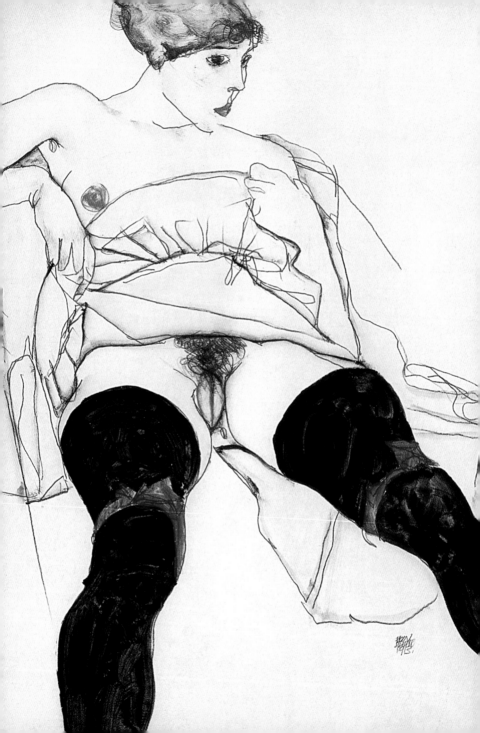

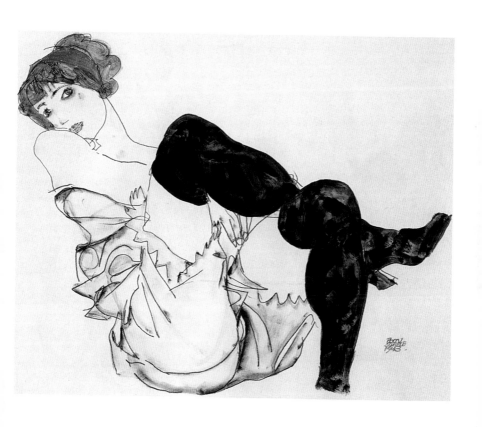

▲ Egon Schiele *Woman in Black Stockings (Valerie Neuzil)*, 1913
◄ Egon Schiele *Woman with Black Stockings*, 1913

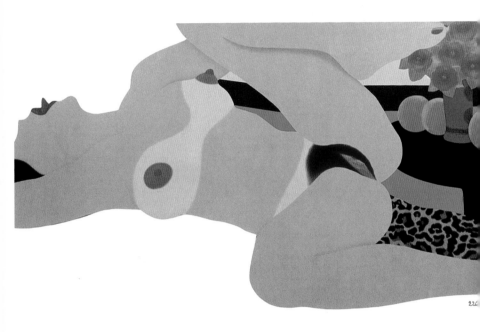

Tom Wesselmann *Great Amercian Nude No. 91, 1967*. Private collection

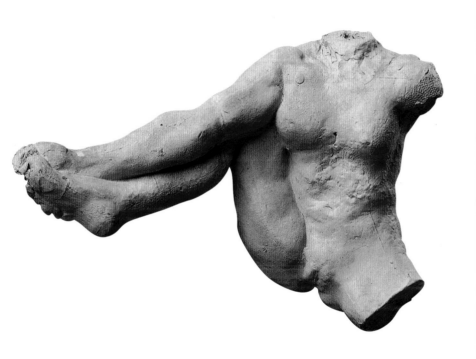

Auguste Rodin *Iris, God's Messenger*, 1890. Paris, Musée Rodin

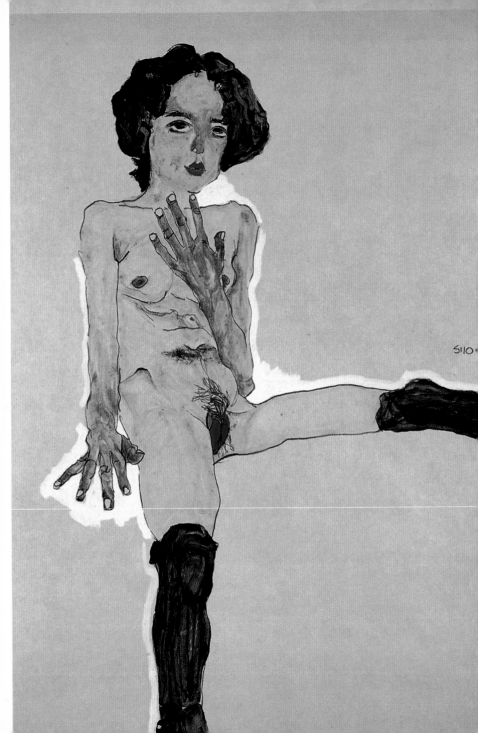

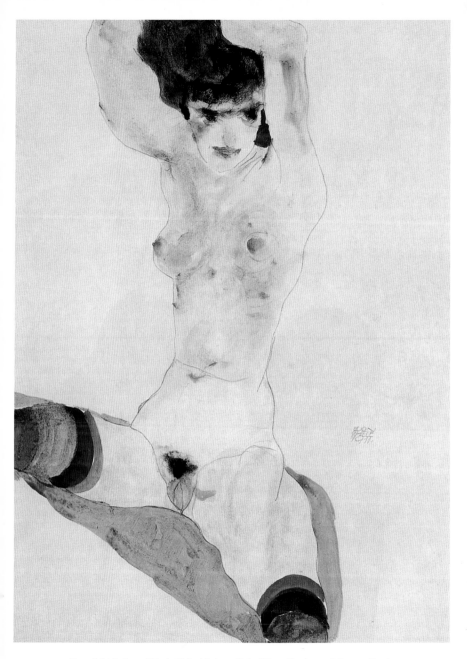

▲ **Egon Schiele** *Seated Nude Girl with Arms Raised Over Head,* 1911. Private collection
◄ **Egon Schiele** *Young Woman with Black Stockings,* 1910. Private collection

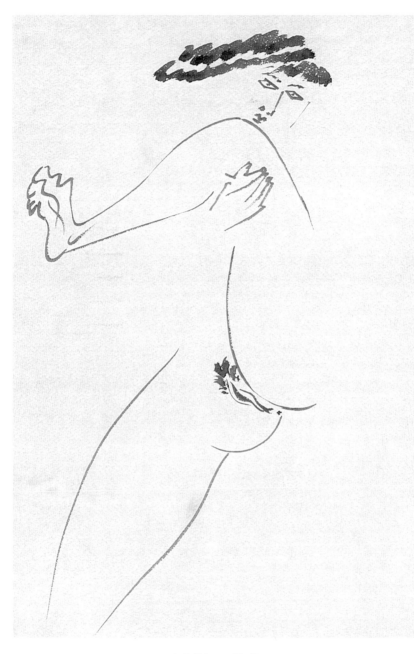

▲ **André Masson** *The Dance,* 1930s
► **Auguste Rodin** *Woman Doing Headstand,* 1900s. Paris, Musée Rodin
►► **Auguste Rodin** *Woman on All Fours*, 1900s. Paris, Musée Rodin

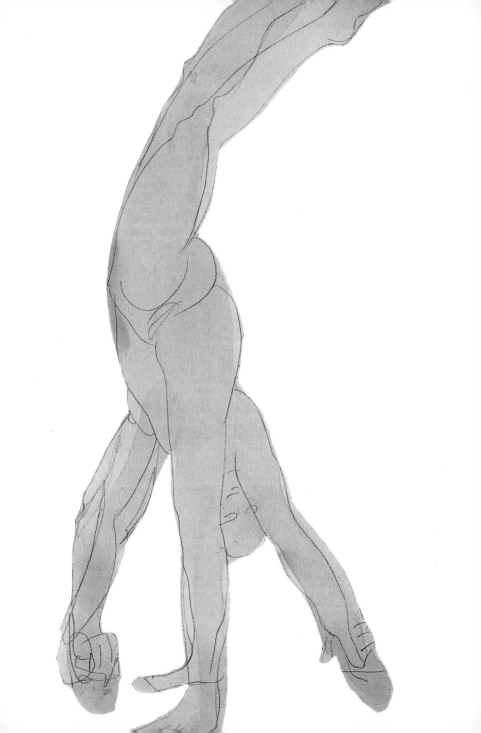

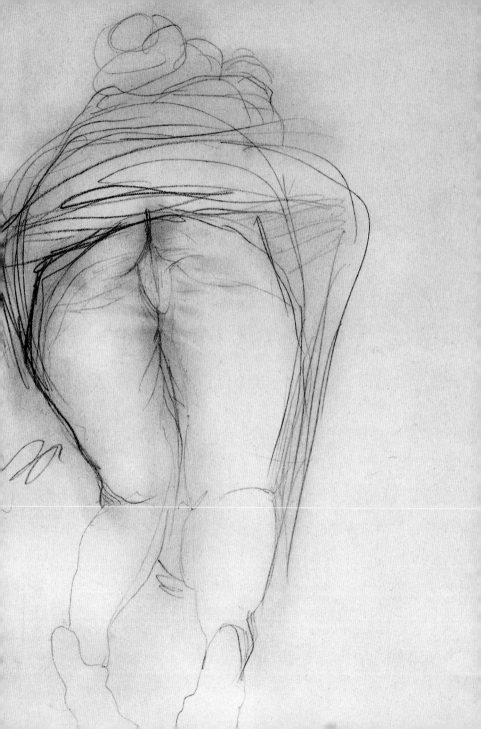

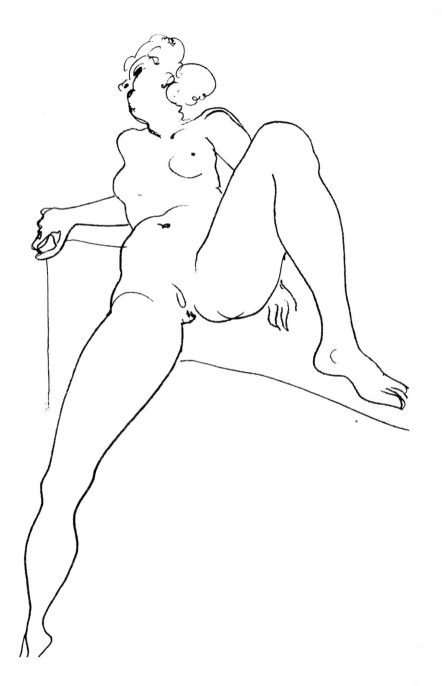

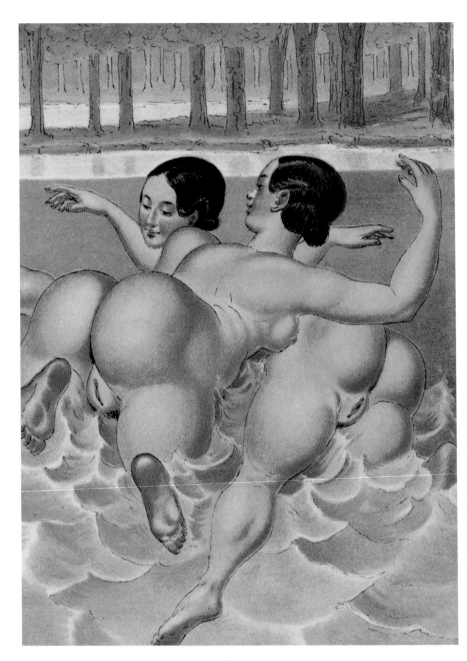

▲ Peter Fendi *Erotic Scene*, c. 1835
◄◄ André Derain *Seated Nude Legs Opened*, 1920s

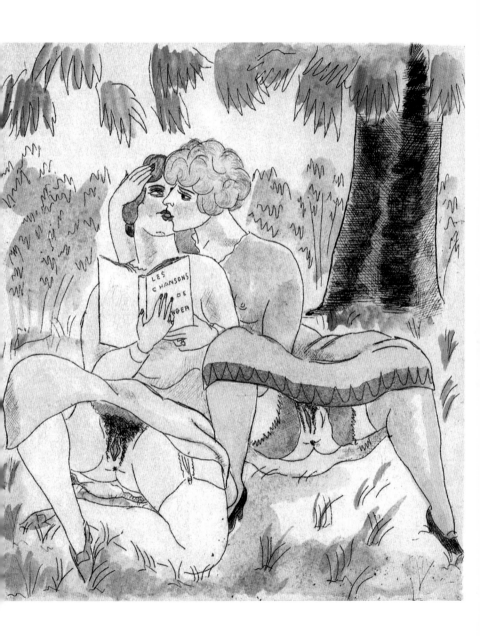

Frontispiece for *Les Chansons Erotiques* by Pierre-Jean de Béranger, c. 1825

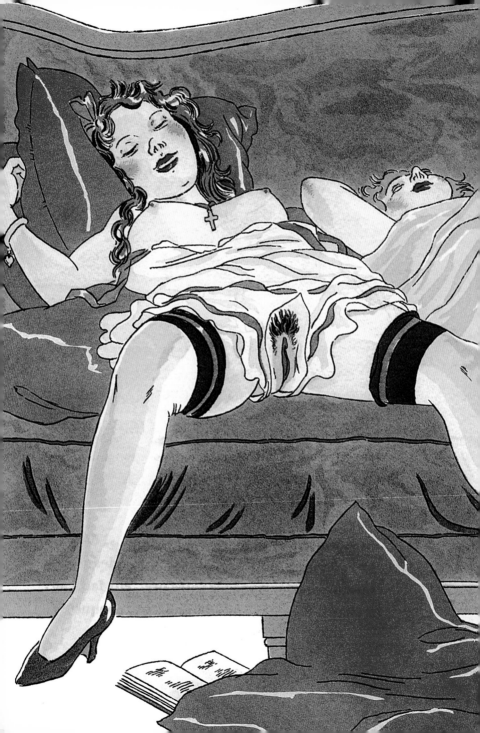

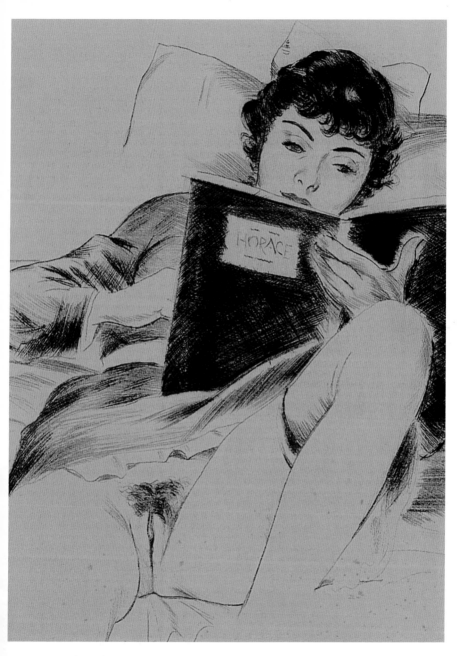

▲ **Georges de Sainte Croix** Illustration for *Nous Deux*, ironically renamed into *Doux Nœuds*, 1920s

◄ **Rojan (?)** Illustration for Raymond Radiguet's poems, published in 1925

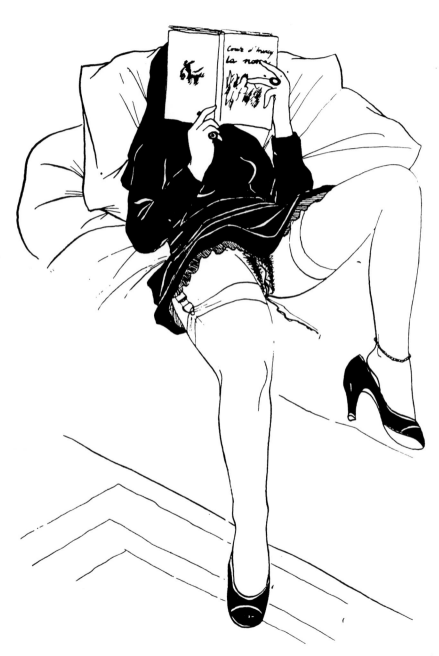

Foujita (?) Illustration for *The Nun*, 1940s

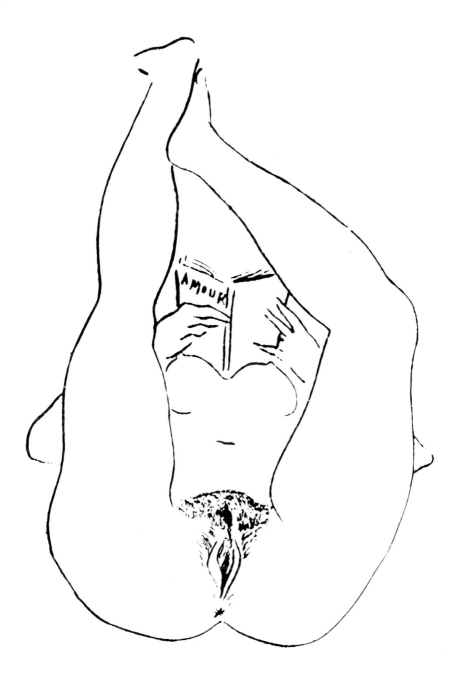

Foujita (?) Illustration for Apollinaire's erotic poems, 1925

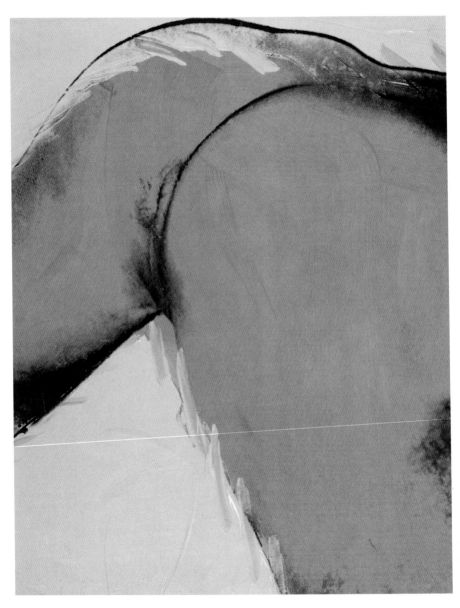

▲ Andy Warhol *Variation Suite*, 1977
▸ Allen Jones *Falling Woman*, 1964. London, Waddington Galleries

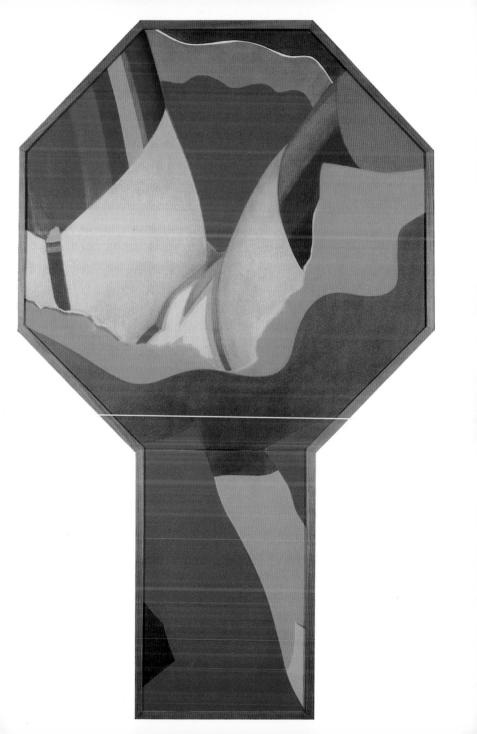

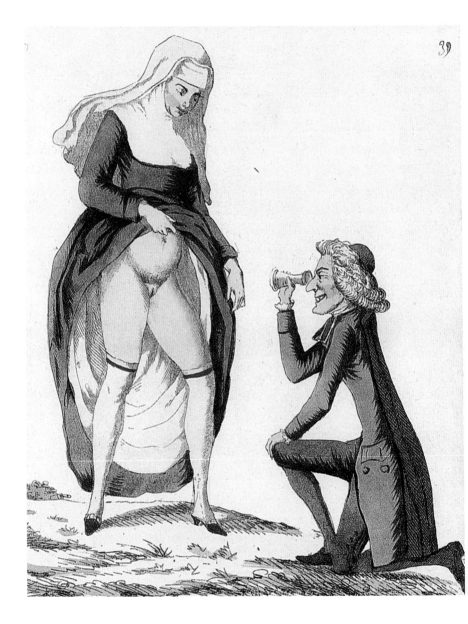

A Priest Consulting His Good Fortune. Sequel to the satires against the nuns,
French Revolution Print, 1789–1792

Observation

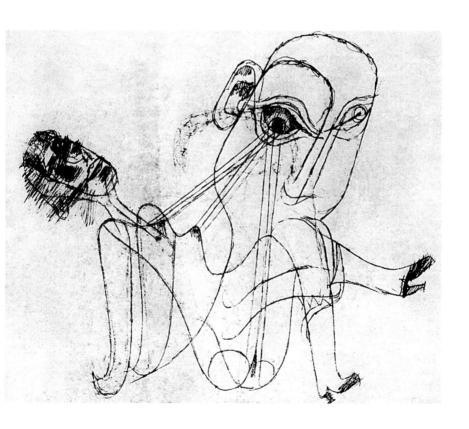

Paul Klee *das Auge des Eros (The Eye of Eros)*, 1919, 53. 13,3 x 21,6 cm. Ink on paper on cardboard.
Morton G. Neumann Family Collection, Chicago.

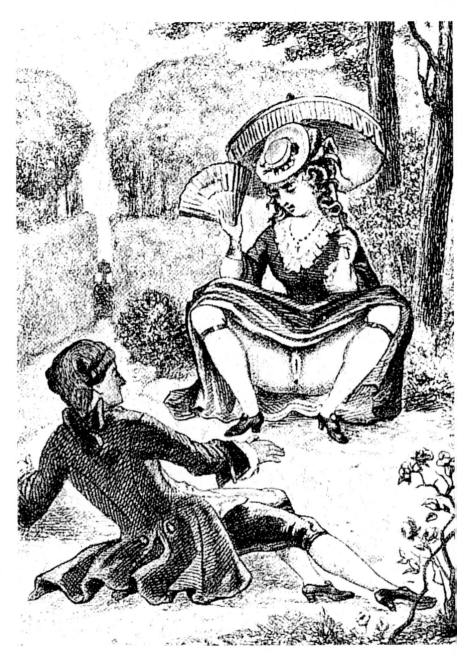

▲ Jules Adolphe Chauvet Engraving for the posthumously published *Memoirs* of Casanova, 19th c.

▸ Jean-Honoré Fragonard *The Luck of the Swing* (detail) 1767. London, The Wallace Collection

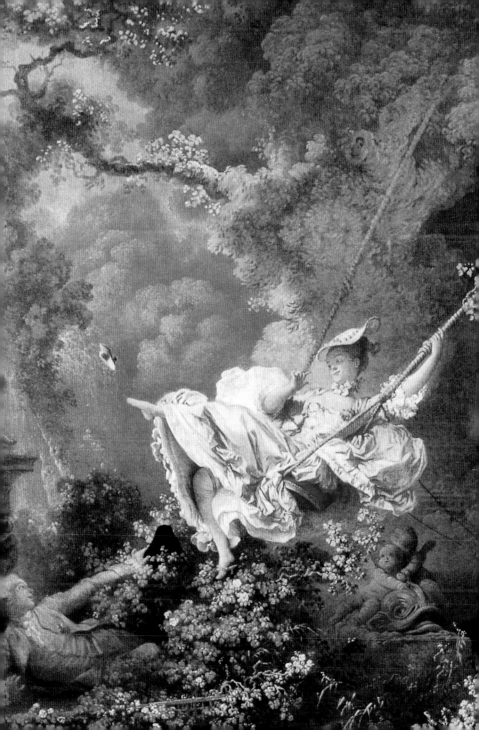

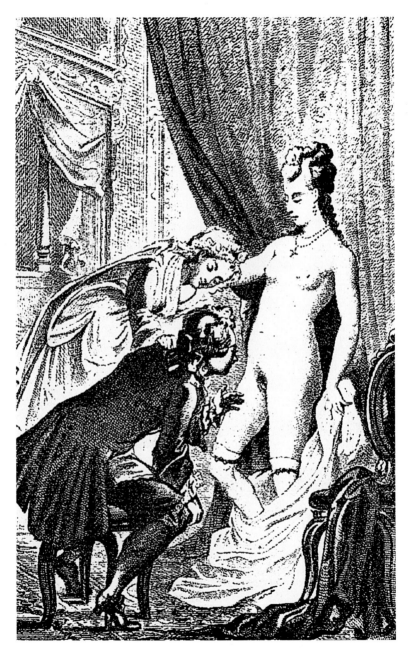

▲► **Jules Adolphe Chauvet** Engravings for the posthumously published
Memoirs of Casanova (1725–1798), 19th c.

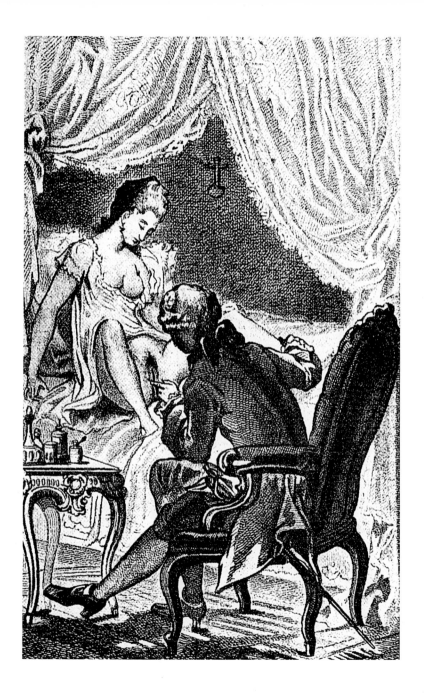

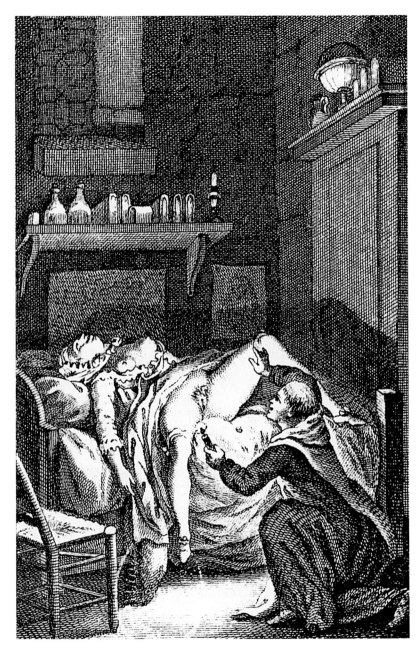

Antoine Borel, engraved by **François Roland Elluin** Illustration
for *Les Mémoires de Saturnin ou Le Portier des Chartreux,* 1787

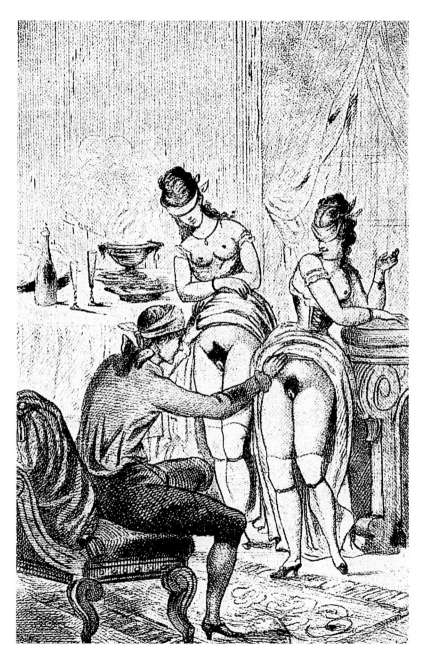

Jules Adolphe Chauvet Engraving for the posthumously published
Memoirs of Casanova (1725–1798), 19th c.

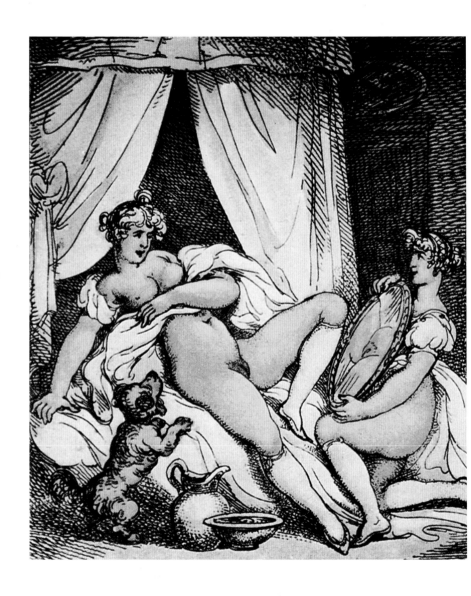

Thomas Rowlandson *La Curiosité des courtisanes,* 1808–1817

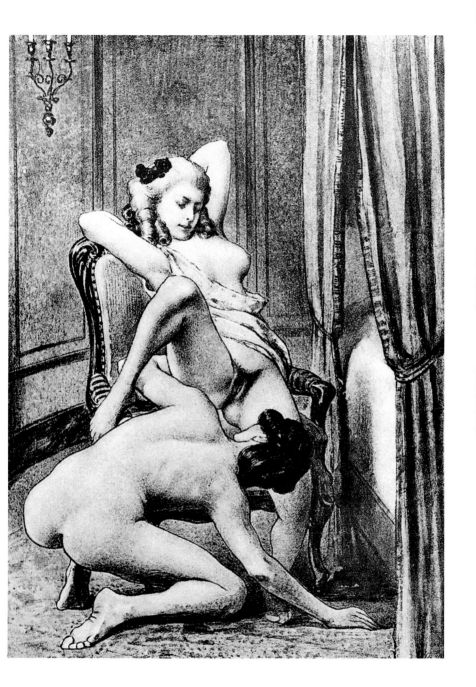

Anonymous *Terra incognita*. Engraving for *Fanny Hill*, c. 1920 69

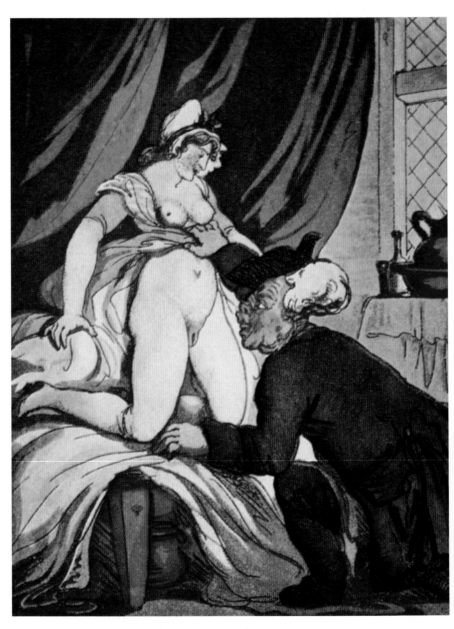

▲ Thomas Rowlandson *L'Indiscrétion du pasteur*, 1808–1817
▸ Thomas Rowlandson *The Swing*, 1808–1817

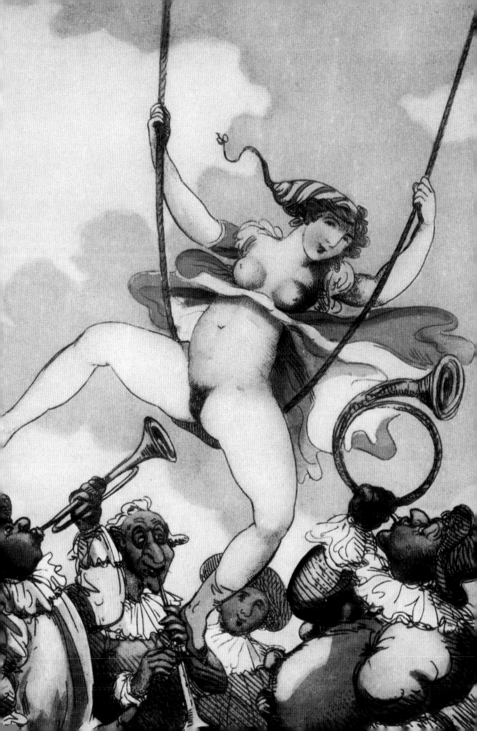

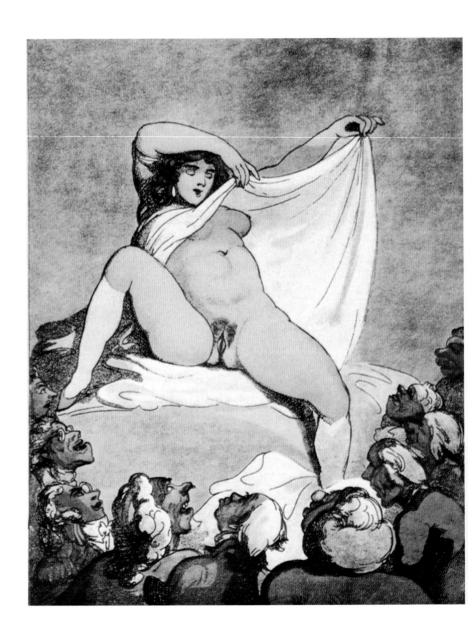

Thomas Rowlandson *La Séance*, 1808–1817

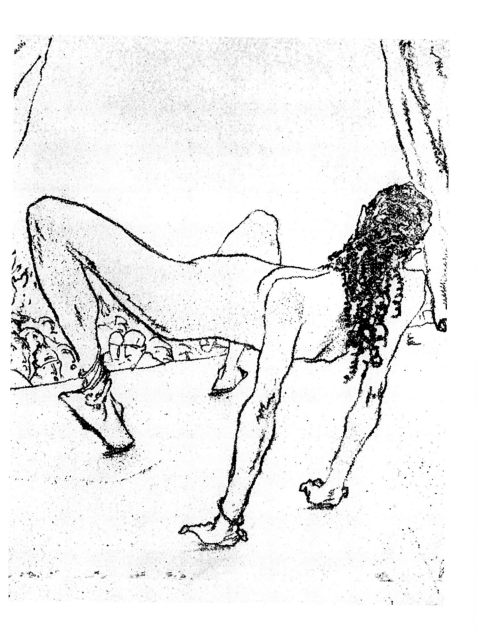

Anonymous *Look!* or *The Counterpart to Rowlandson,* c. 1920s

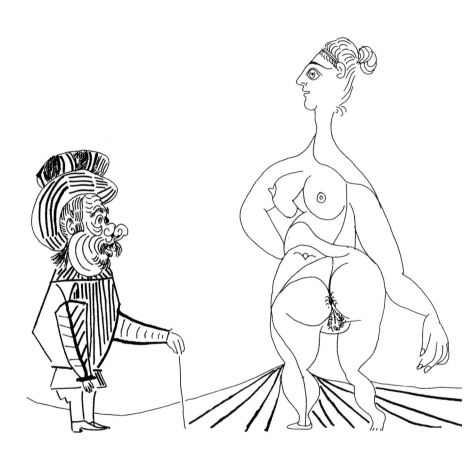

Pablo Picasso Erotic engraving, dated 12.4.1970, exhibited for the first time in 1973 at the gallery Louise Leiris, Paris

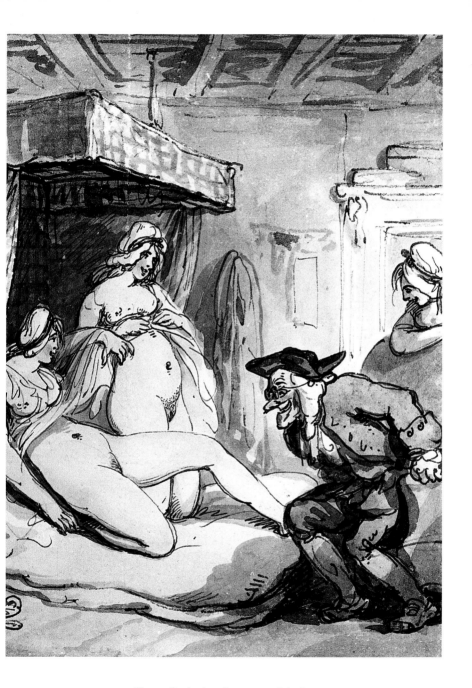

Thomas Rowlandson *Souvenance*, 1808–1817

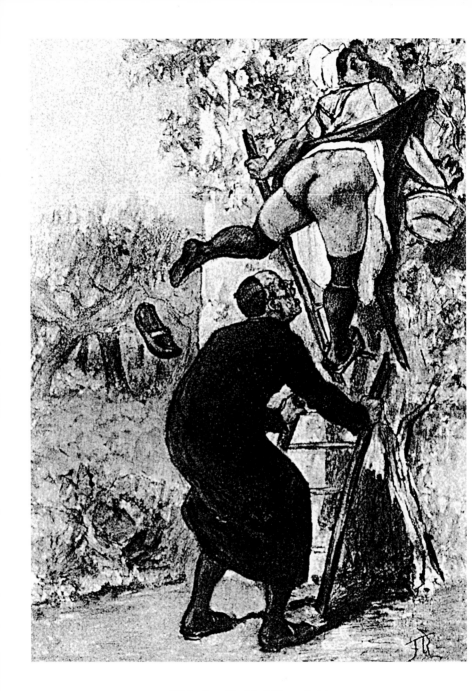

Félicien Rops *The Priest's Vineyard*, 1878

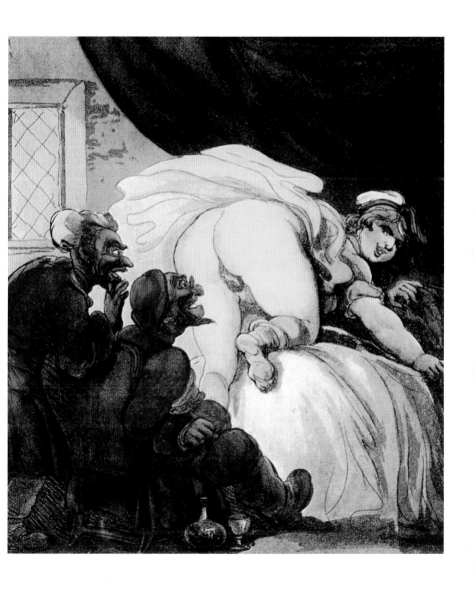

▲ **Thomas Rowlandson** *Susanna and the Elders*, 1808–1817
►► **Anonymous** Engraving for *Dom Bougre ou Le Portier des Chartreux*, 1741

77

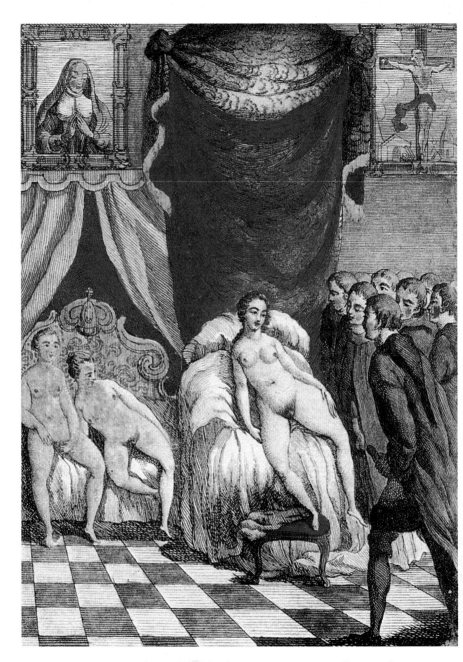

▶ **Anonymous** *The Members of the Clergy Ensuring Her Virginity*. Illustration for
Voltaire's *La Pucelle d'Orléans* (Jeanne d'Arc), 19th c.

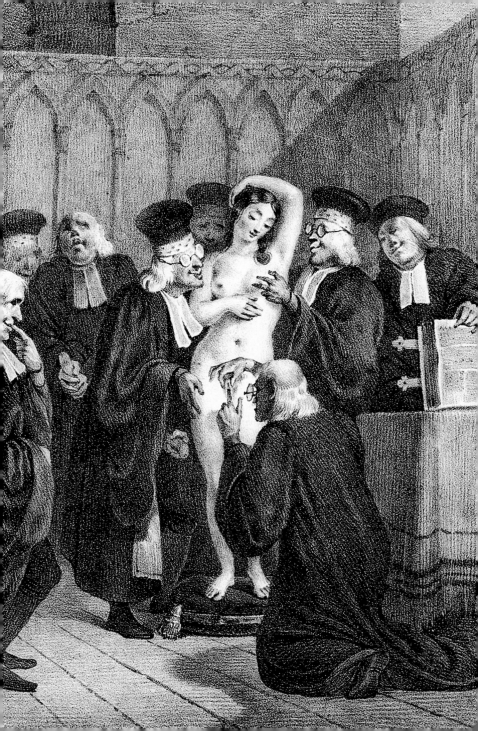

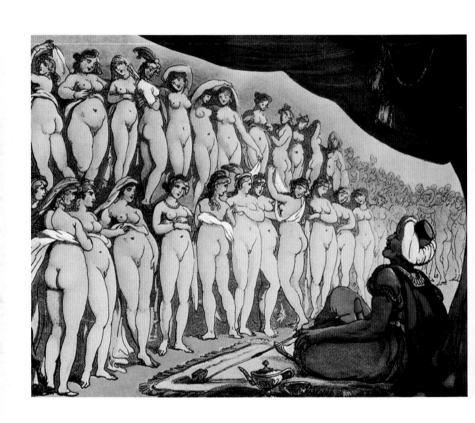

Thomas Rowlandson *The Harem,* 1808–1817

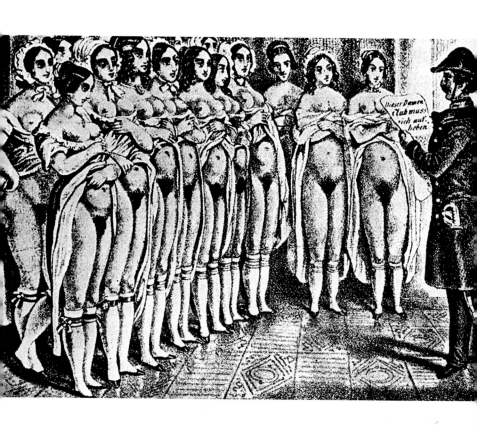

Anonymous *Democratic Venus. Inspection of the prostitutes.* Popular etching, 1848 81

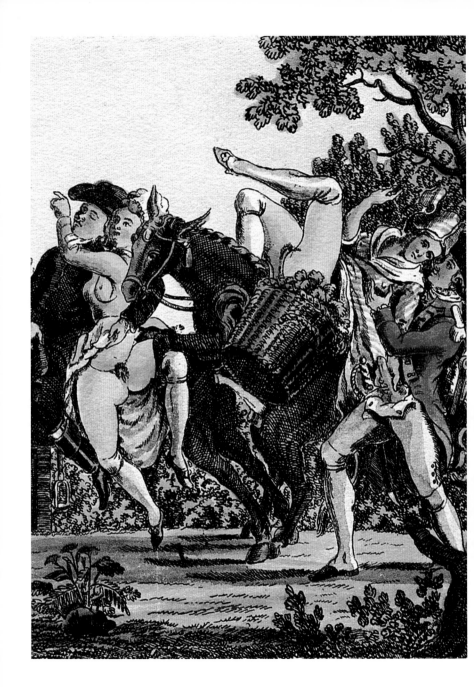

William C. B. *Les Bigarrures. Le Joyeux accident* (detail), 1799

Philibert Louis Debucourt *Hunting*, c. 1800

Eric Fischl *Bad Boy*, 1981. New York, Courtesy Mary Boone Gallery

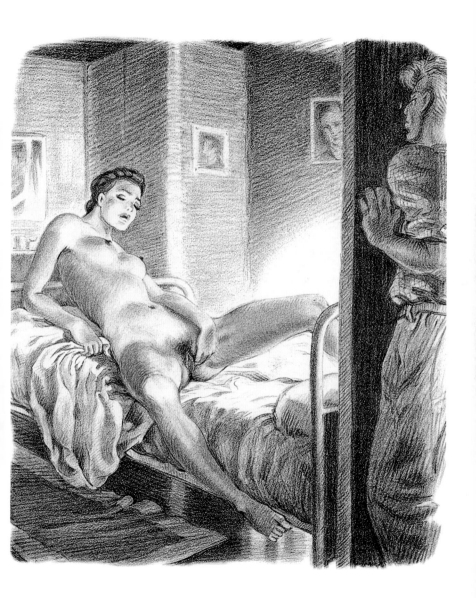

Anonymous Illustration for *Clayton's Collège*. Classical erotic scene from the 1950s 85

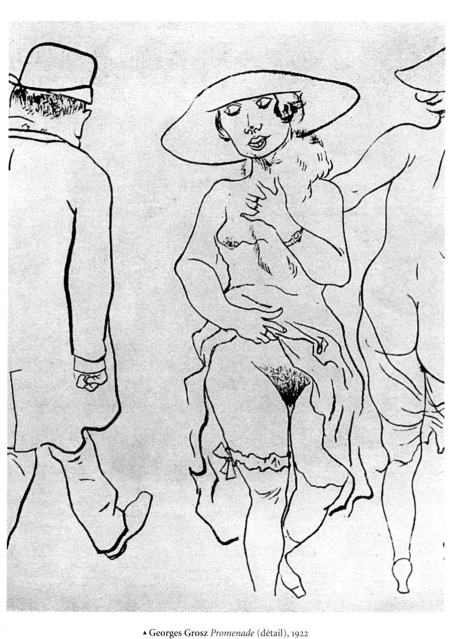

▲ **Georges Grosz** *Promenade* (détail), 1922
◄ **Gottfried Helnwein** *Lulu* (detail), 1988. Collection Georg Lutz

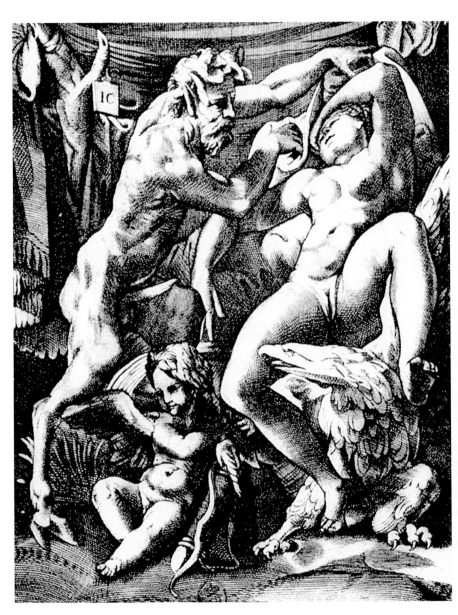

▲ **Gian Jacopo Caraglio** Engraving after Hans von Aachen's *Jupiter and Callisto*, 16th c.

▸ **Pablo Picasso** *Nymph and Satyr*, 1968

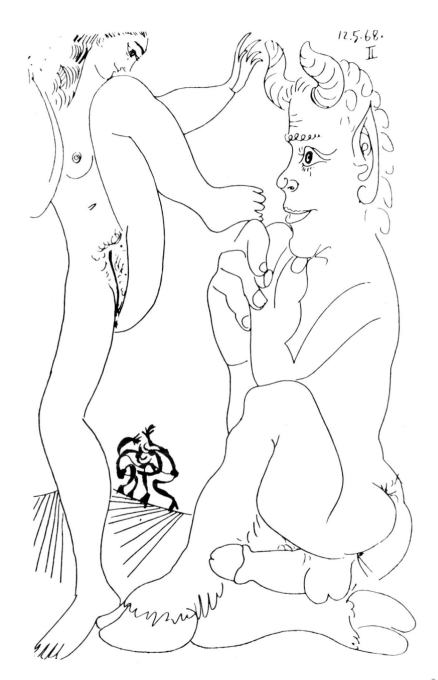

12.5.68.
II

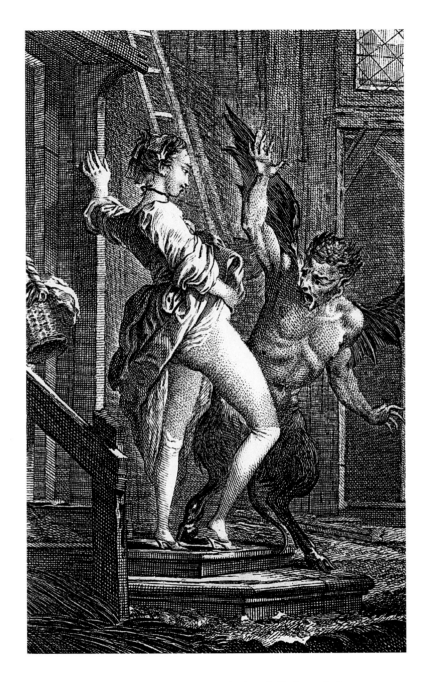

Charles Eisen Illustration for La Fontaine's tale *Le diable de Papefiguière*, 1674

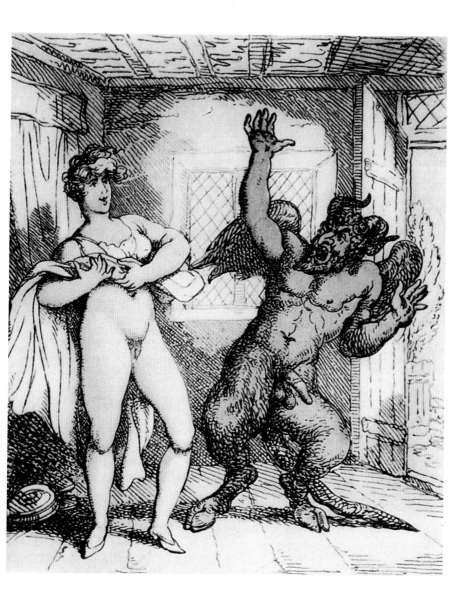

Thomas Rowlandson *Le Regard du diable*, 1808–1817

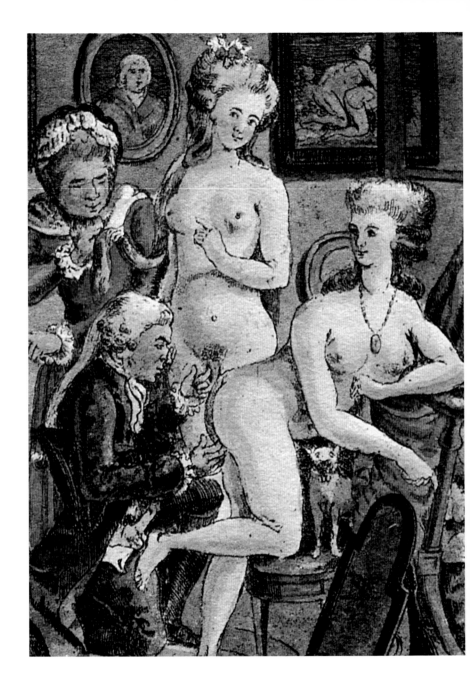

William C. B. *Les Bigarrures. Les Vieux Foux* (detail), 1799

Exploration

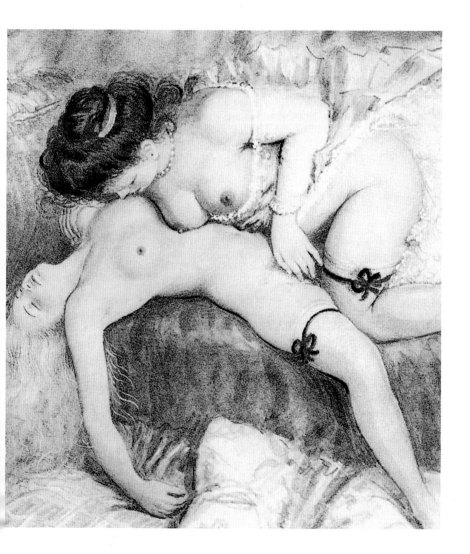

Paul Emile Bécat Illustration for Verlaine's *Oeuvres Libres* (detail), 1948

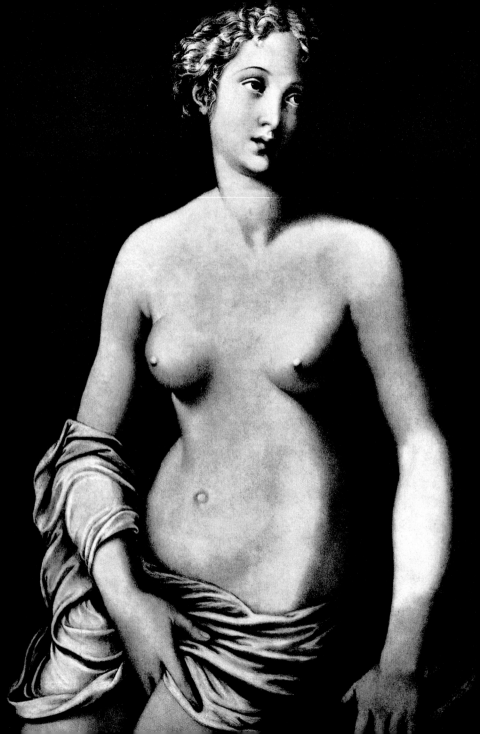

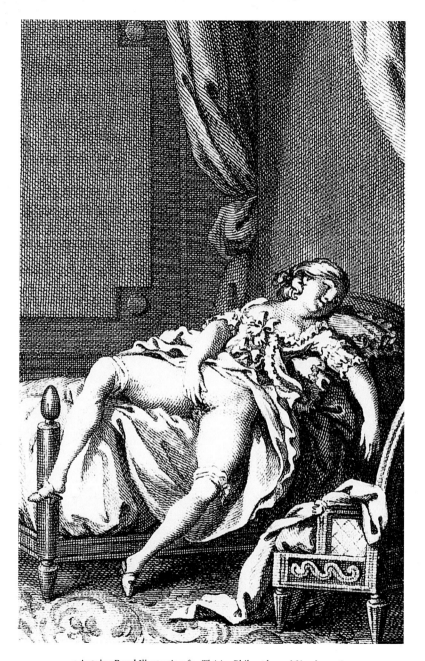

▲ **Antoine Borel** Illustration for *Thérèse Philosophe ou Mémoires*, 1785
◄ **Baldassare Peruzzi** *Venus with agile finger*, early 16th c. Rome, Galleria Borghese

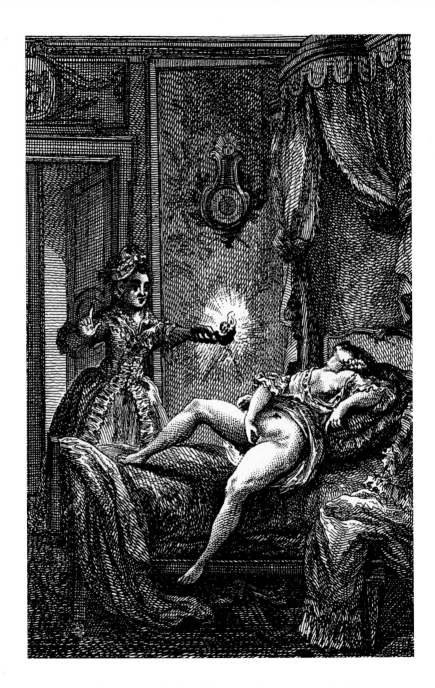

▲▶ **Anonymous** Illustrations for *Thérèse Philosophe ou Mémoires*, attributed to Diderot, c. 1785

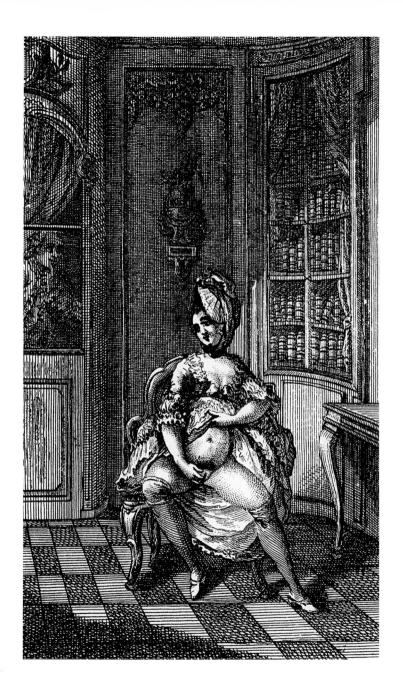

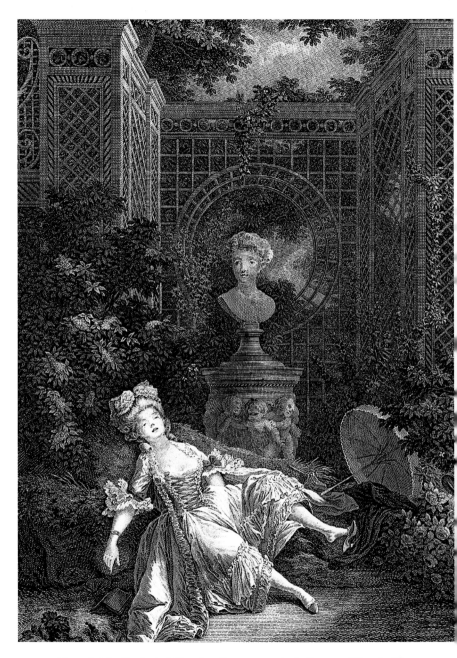

Pierre-Antoine Baudouin *Solitary Love*. Copper engraving by Emmanuel Ghendt, 18th c.
Paris, Bibliothèque Nationale

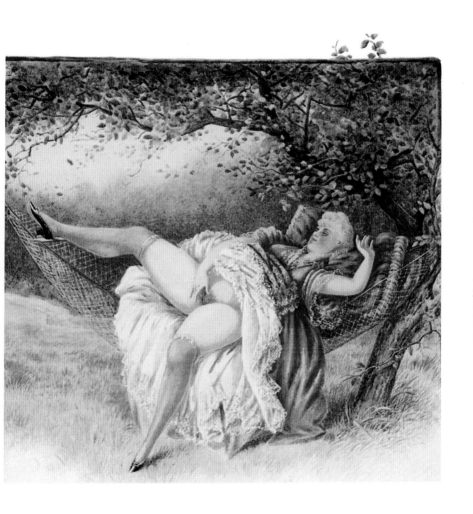

Anonymous *The Secret Life of the Bourgeoisie.* Victorian lithograph, late 18th c.

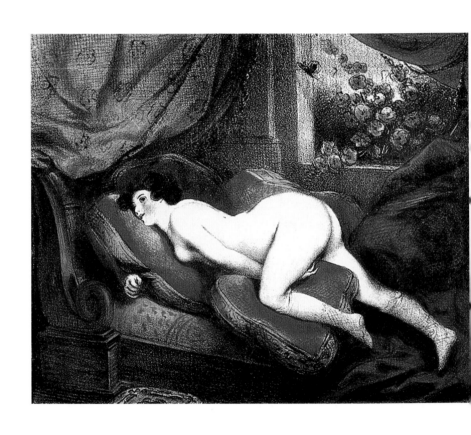

Achille Devéria Illustration for the novel *Gamiani or A Night of Excess* by
Alfred de Musset, c. 1848

Berthomme Saint-André Illustration for the novel *Gamiani or A Night of Excess* by
Alfred de Musset, 1930s

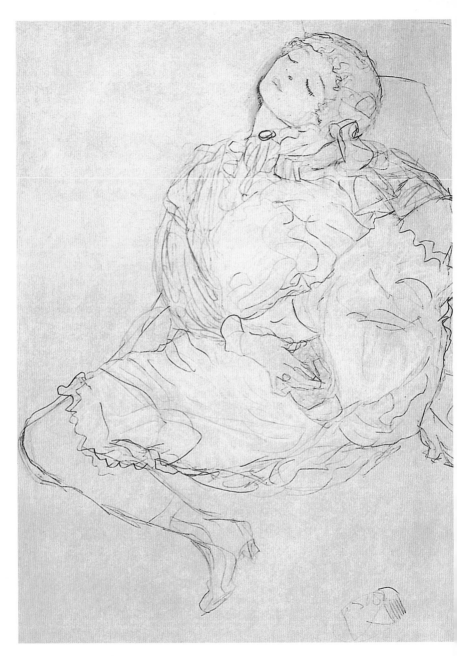

▴ **Gustav Klimt** *Woman Sitting with Spread Thighs,* 1916/17. Vienna, Historisches Museum
▸ **Christian Schad** *Girlfriends,* 1930. Private collection

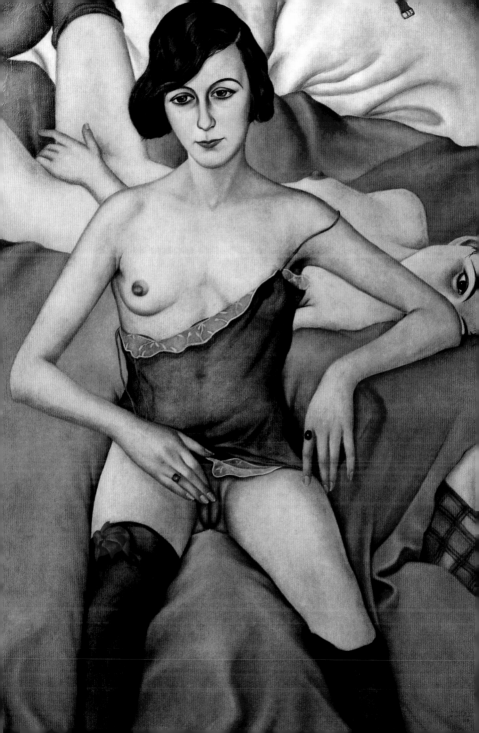

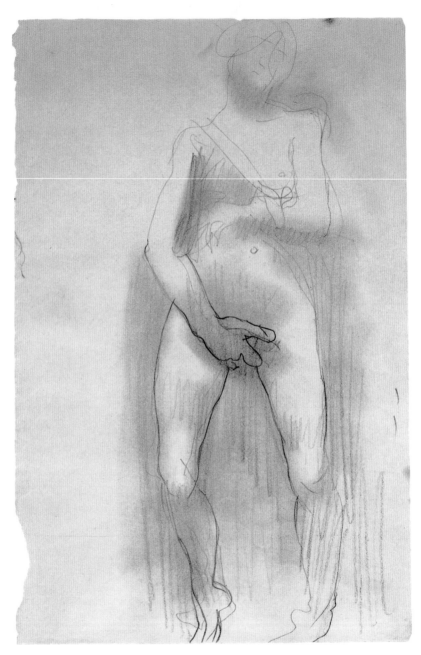

Auguste Rodin *Standing Woman, One Hand between Her Thigh*, c. 1900.
Paris, Musée Rodin

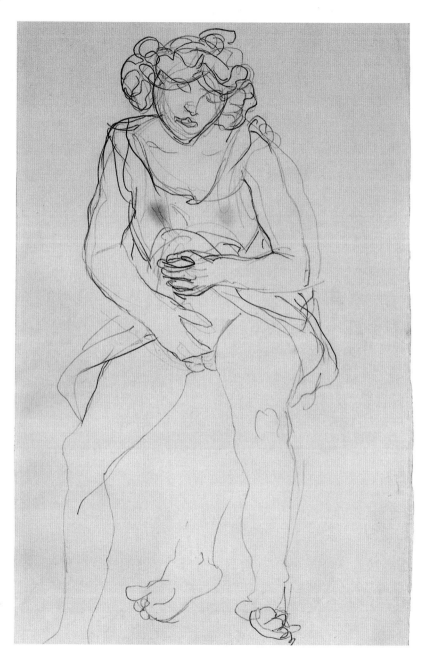

Auguste Rodin *Woman Raising Her Garment, the Other Hand on the Belly*, c. 1900.
Paris, Musée Rodin

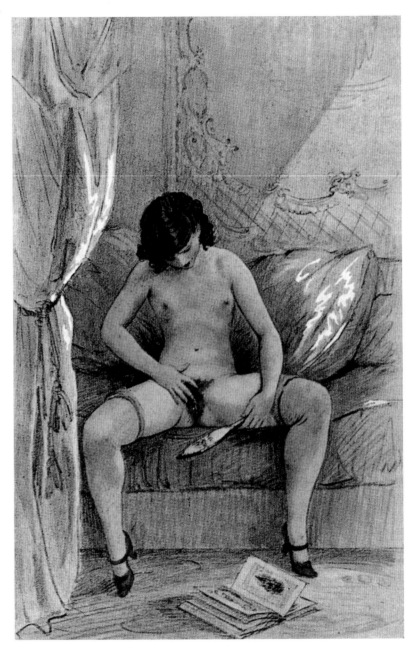

Anonymous (Paul-Emile Bécat ?) Illustration for *An Up-to-date Young Lady*,
a best-seller by Helena Varley, 1920–1930s

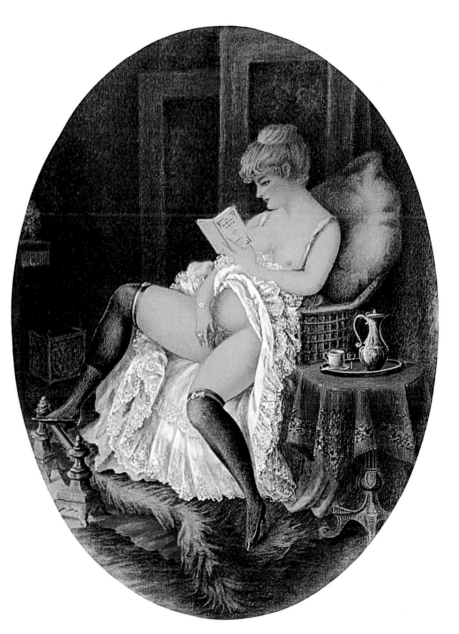

▴ **Anonymous** Victorian lithograph
▸▸ **Berthomme Saint-André** *Reading*, 1930s

▲ Foujita (?) Illustration for an anonymous licentious novel, 1930s
 ▶▶ **Master with the Banderoles** *The Joys of the Bath*, 15th c.

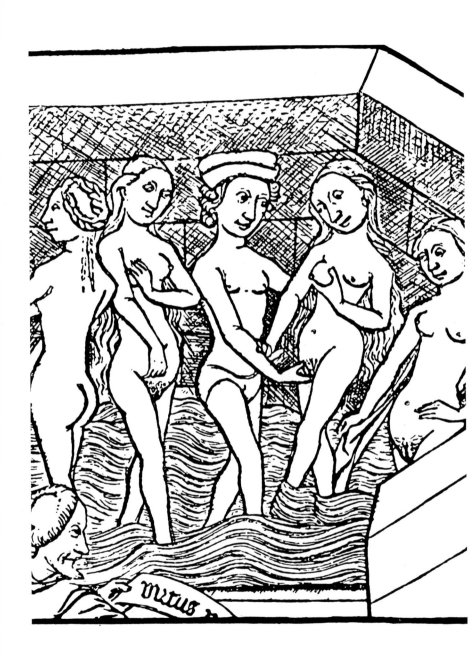

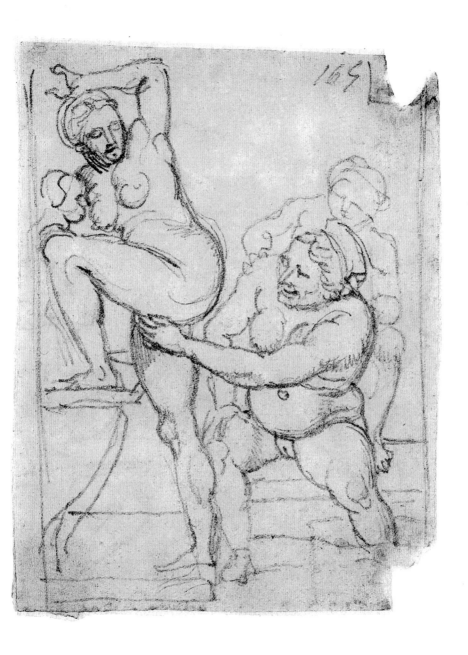

111

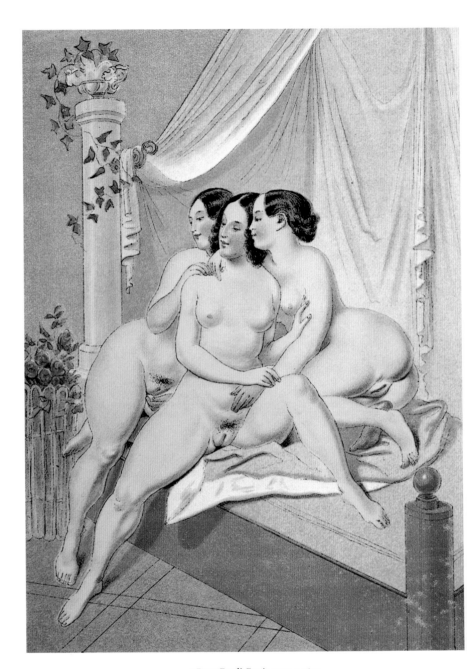

▲ Peter Fendi *Erotic scene,* c. 1835

◂◂ Jean-Auguste-Dominique Ingres *Three Women at the Public Bath,* from his sketchbook, 1800–1806

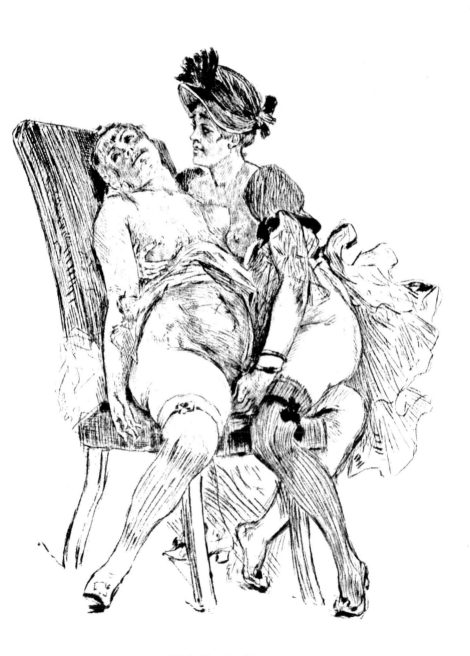

Félicien Rops *En visite*, 1880

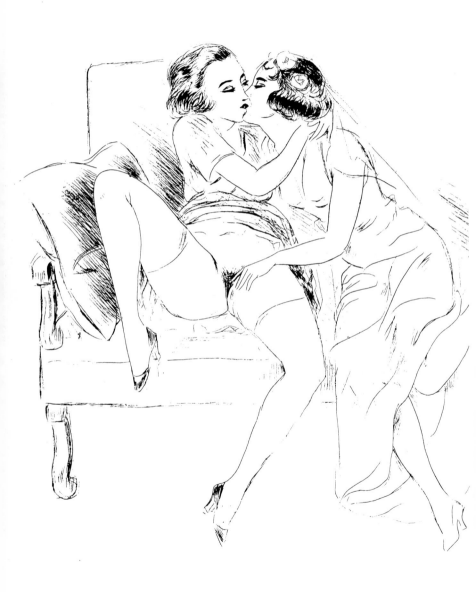

▴ **Anonymous** *Le Mariage de Suzon,* c. 1925
▸ **Gerda Wegener** Illustration (detail) for *Les Délassements d'Eros,* early 1920s

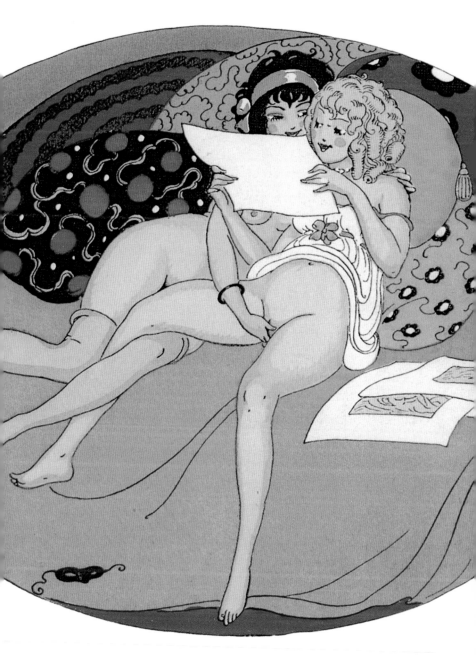

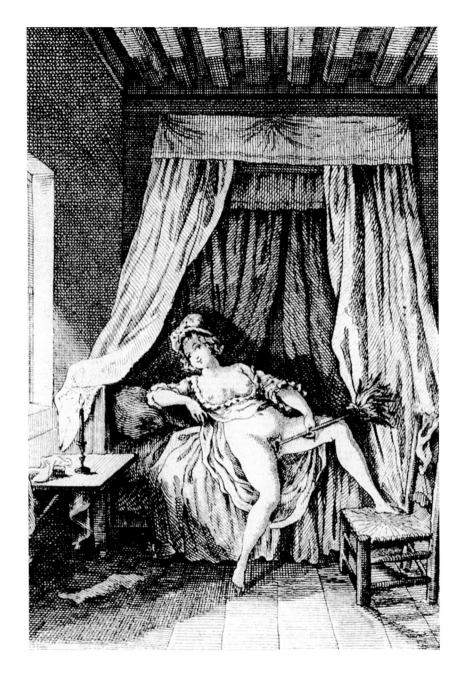

Anonymous *La Servante du Curé*. Engraving for *Les Heures de Paphos*, 1787

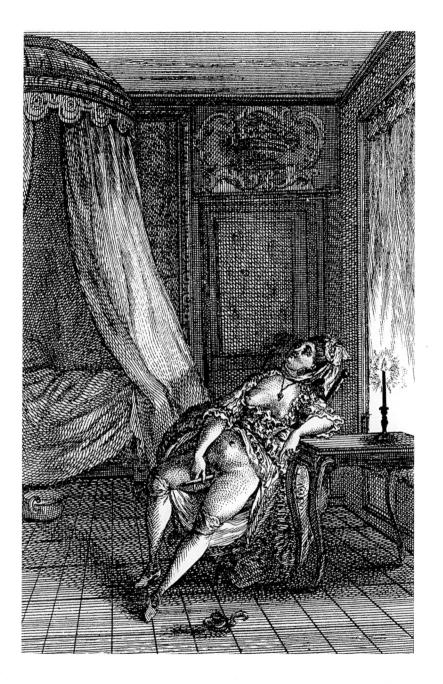

Anonymous Illustration for *Thérèse Philosophe ou Mémoires*, attributed to Diderot, c. 1748 117

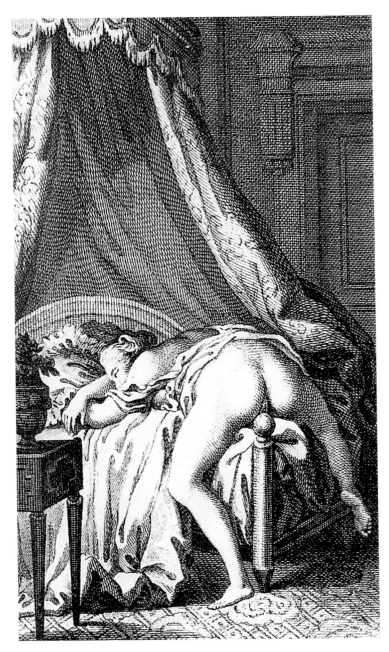

Antoine Borel, engraved by **François Roland Elluin** Illustration
for *Thérèse Philosophe ou Mémoires*, attributed to Diderot, 1785

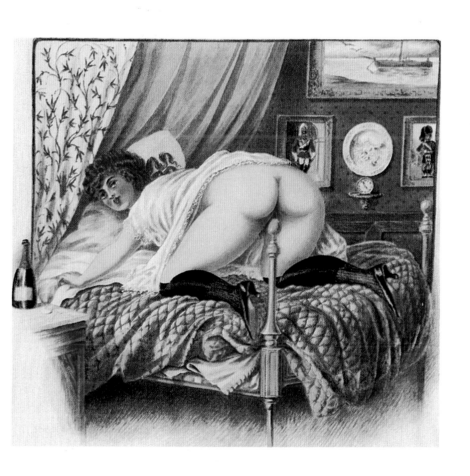

Anonymous *The Secret Life of the Bourgeoisie.* Victorian lithograph, late 18th c.

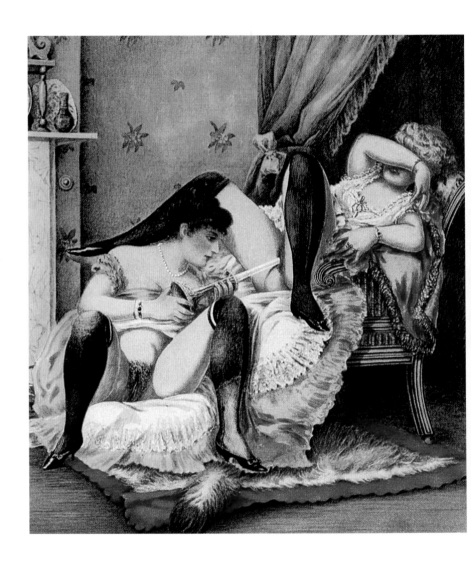

▲▶ **Anonymous** *The Secret Life of the Bourgeoisie.* Victorian lithographs, late 18th c.

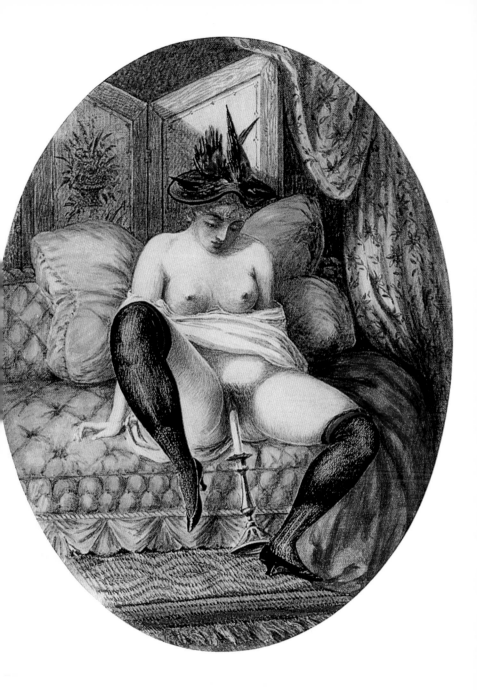

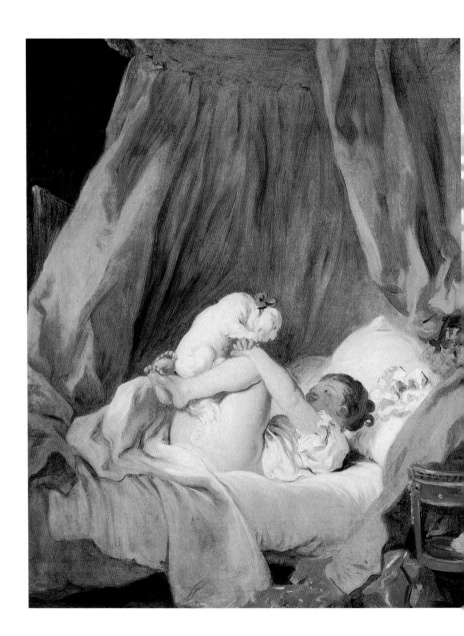

Jean-Honoré Fragonard *La Gimblette (Girl Playing with a Dog),* 1770. Munich, Alte Pinakothek

Foujita (?) Illustration for *The Nun*, 1940s

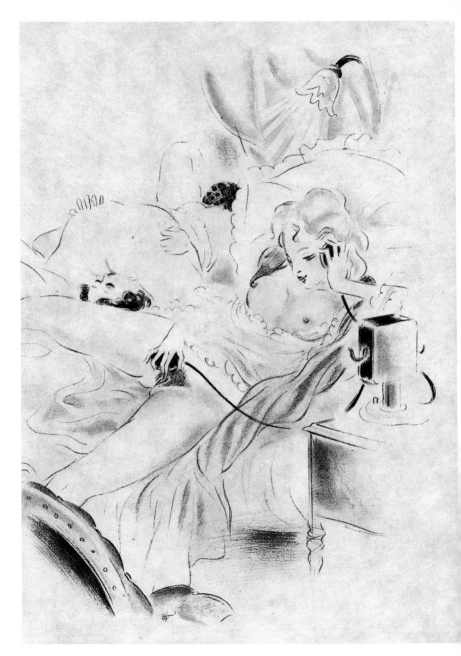

▴ **Anonymous** Illustration for Pierre Louÿs's poems, 1899
▸ **George Grosz** *With Two Woman* (detail), late 20's, early 30's

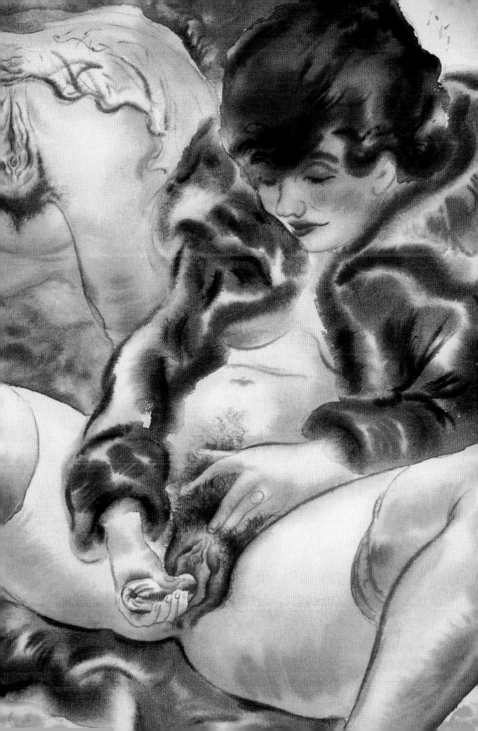

Roger-Jean-Lucien Testu Illustration in *Les Belles Manières*, 1964

Tomi Ungerer Illustration in Fornicon, 1969

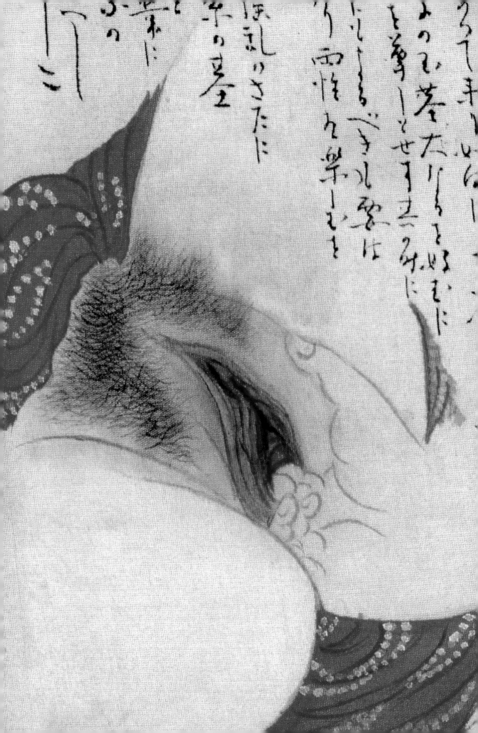

▲ **Robert Crumb** May I ?, 1970s
◄ For medical use: *The Vaginal Tough.* Japanese roll painting on silk, c. 1850 129

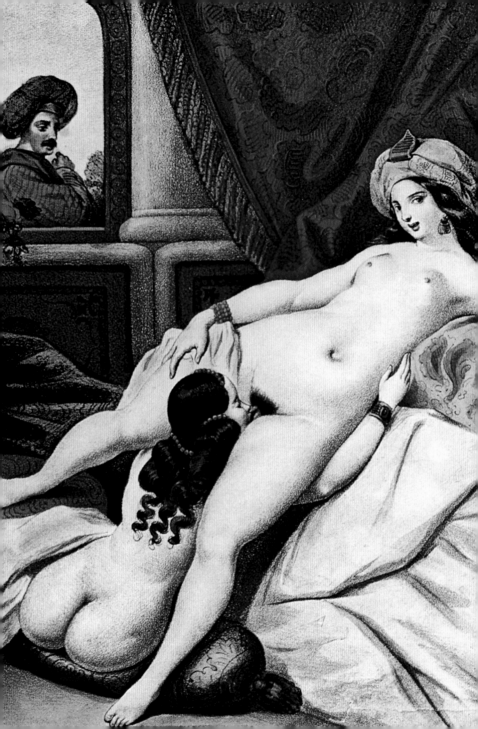

Picnic

▲ **Anonymous** Illustration for Pierre Louÿs's *Three Daughters of their Mother*, 1920s
◄ **Achille Devéria** Illustration for *The Thousand Nights and a Night*, c. 1840

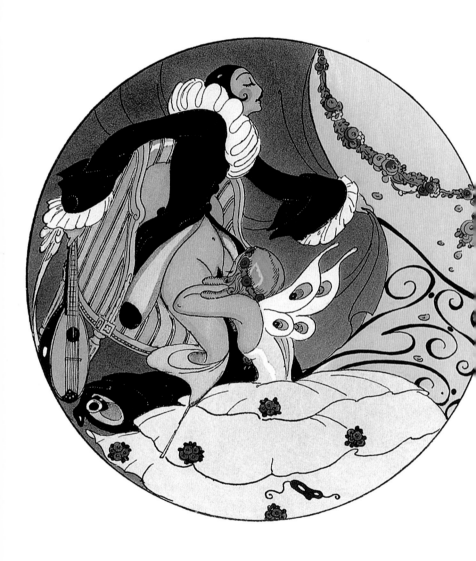

◂▸ **Gerda Wegener** Illustrations for *Les Délassements d'Eros*, early 1920s

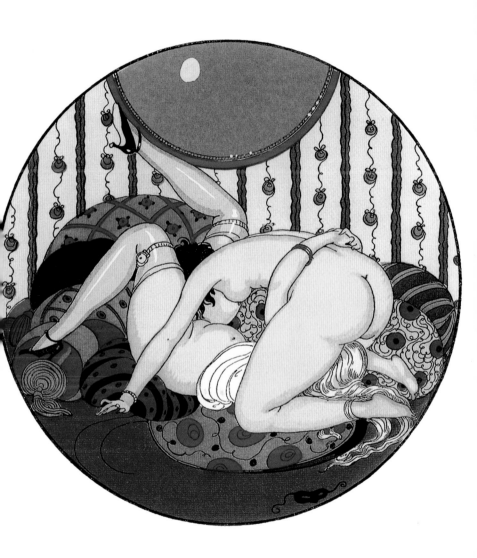

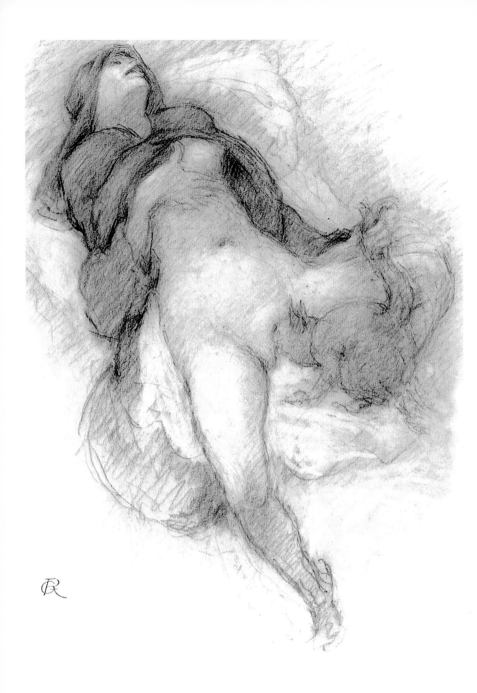

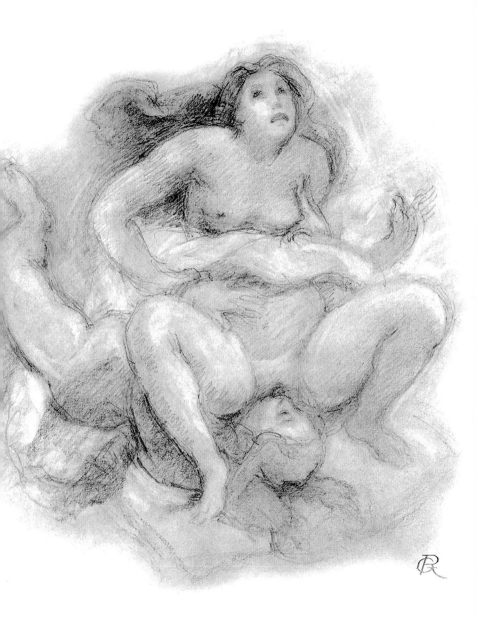

◄▲ **Richard Guino** Erotic drawings by the sculptor of Pierre Auguste Renoir, 1930–1940s

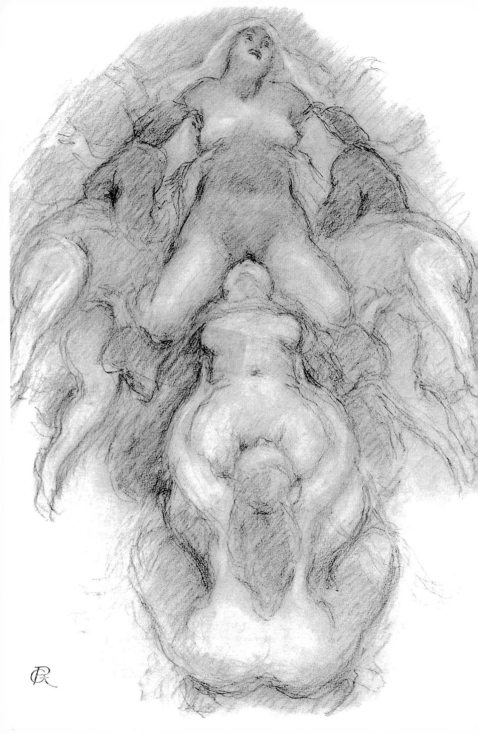

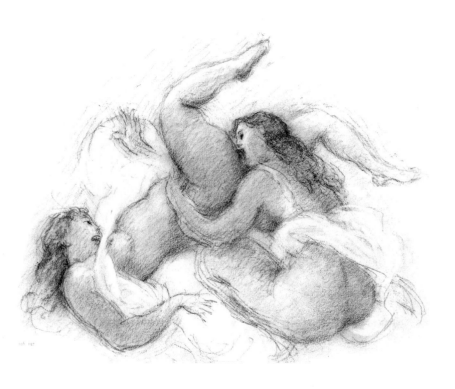

▲◄ **Richard Guino** Erotic drawings by the sculptor of Pierre Auguste Renoir, 1930–1940s 137

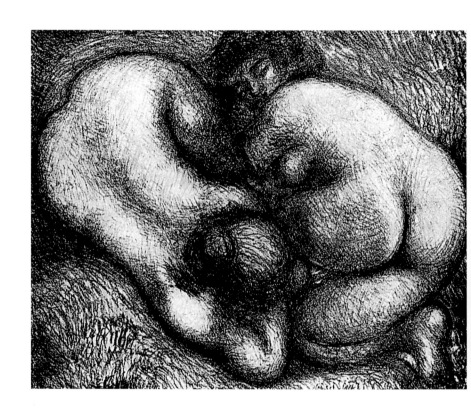

Aristide Maillol *Sixty-Nine*, c. 1930

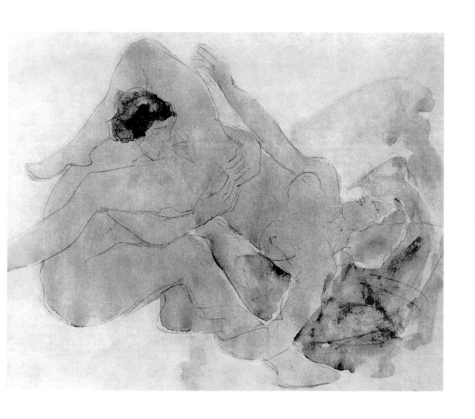

Auguste Rodin *Oblivion*. Watercolour (destroyed in 1940), 1900s

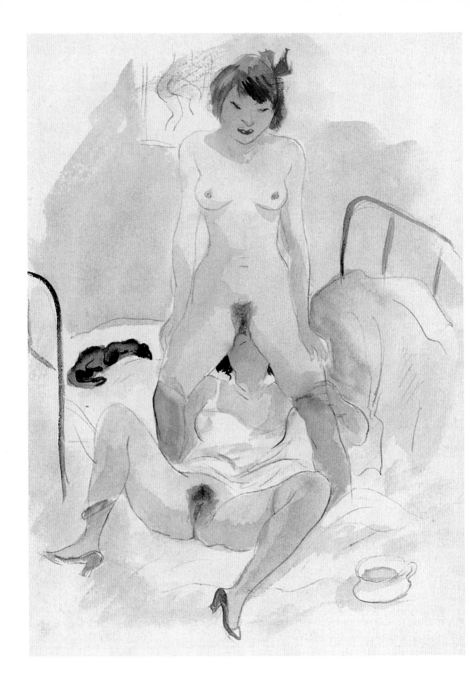

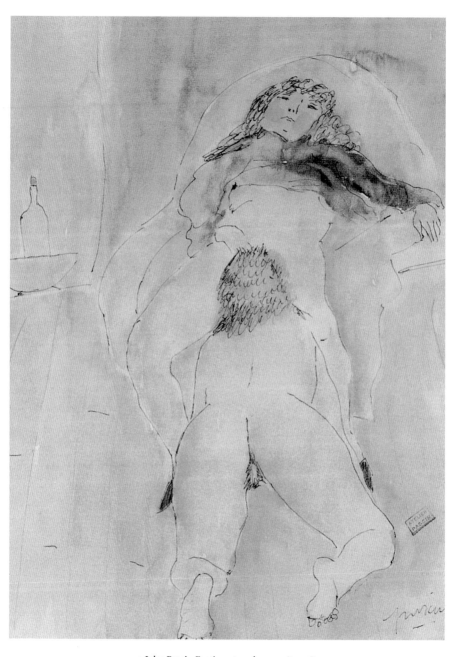

▲ **Jules Pascin** Erotic watercolour, 1926–1928
◀ **Otto Schoff** Watercolour for *Allerlei Liebesspiele*, c. 1925

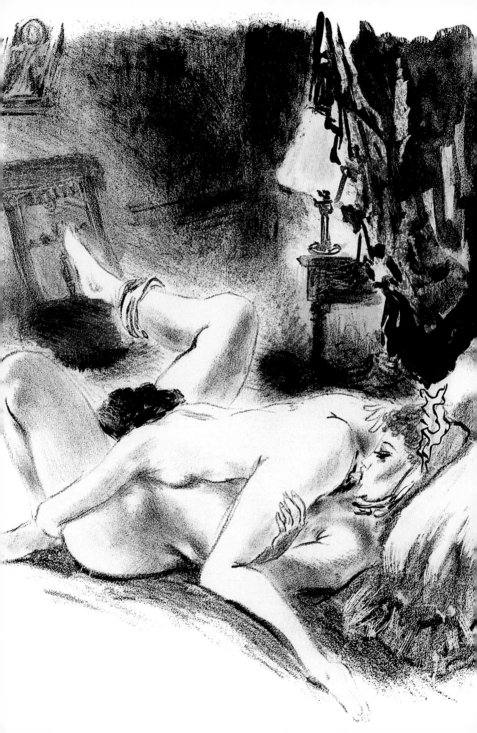

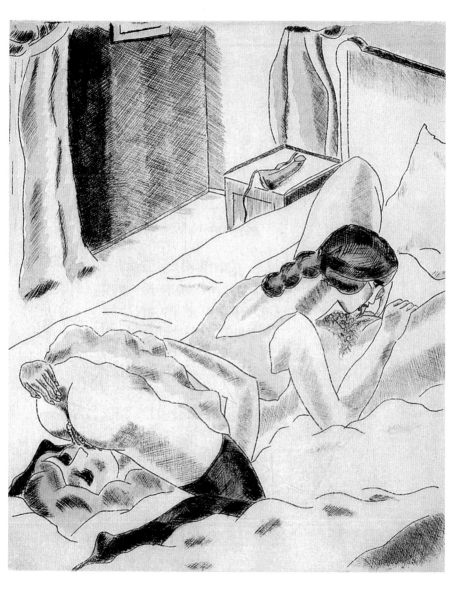

▲ *The Two Sisters.* Illustration for *Les Chansons Erotiques* by Pierre-Jean de Béranger, c. 1825
◄ **Berthomme Saint-André** Illustration for Musset's *Gamiani or A Night of Excess*, 1930s
►► **Anonymous** Illustration for *The Book of Lust* by Pierre Lacombière, 1920–1930s

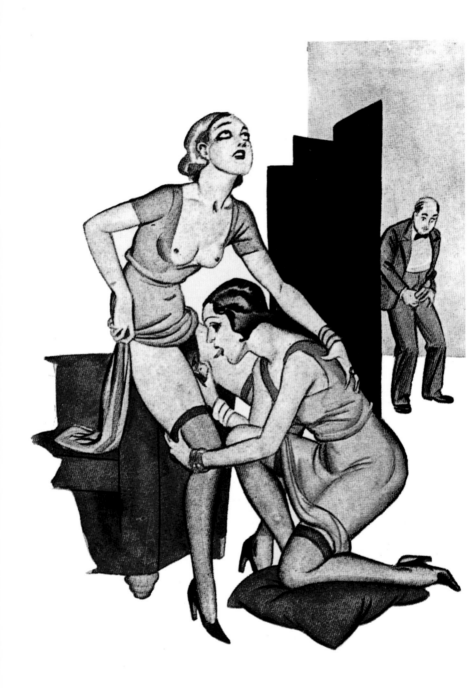

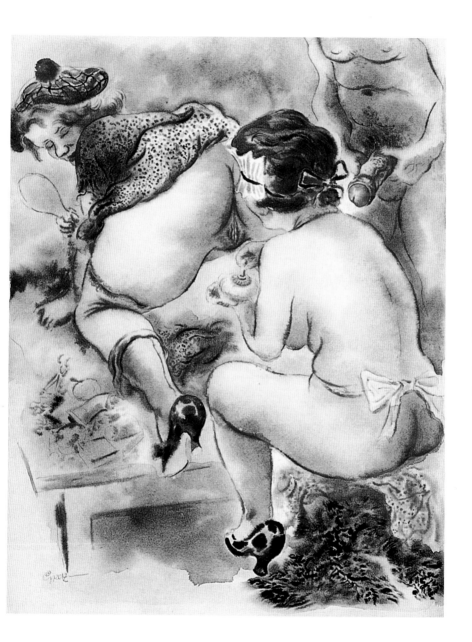

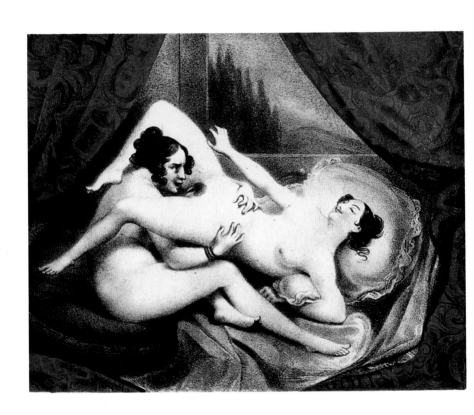

▲ **Achille Devéria** Illustration for the novel *Gamiani or A Night of Excess* by Alfred de Musset, c. 1848

◄◄ **George Grosz** From a series of watercolours and drawings with social implications, 1920–1930s

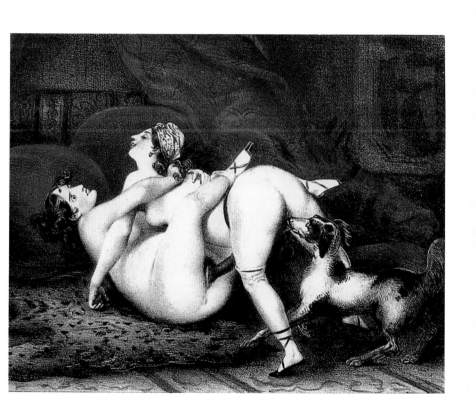

Achille Devéria Illustration for the novel *Gamiani or A Night of Excess* by Alfred de Musset, c. 1848 147

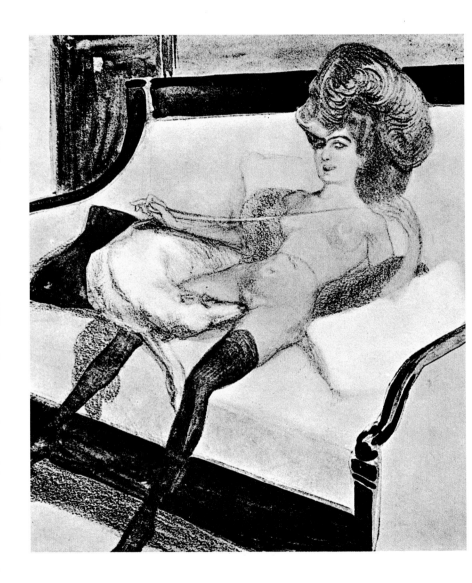

▲ **Franz von Bayros** *Tales of the Dressing Table: The Blue Feather*, 1908
▸ **Foujita** (?) Illustration for an anonymous licentious novel, c. 1925

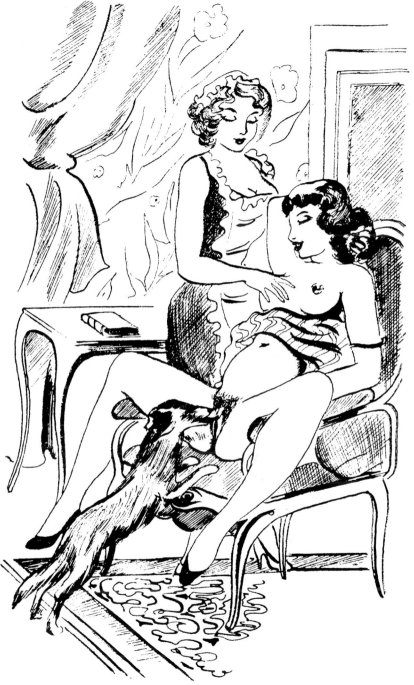

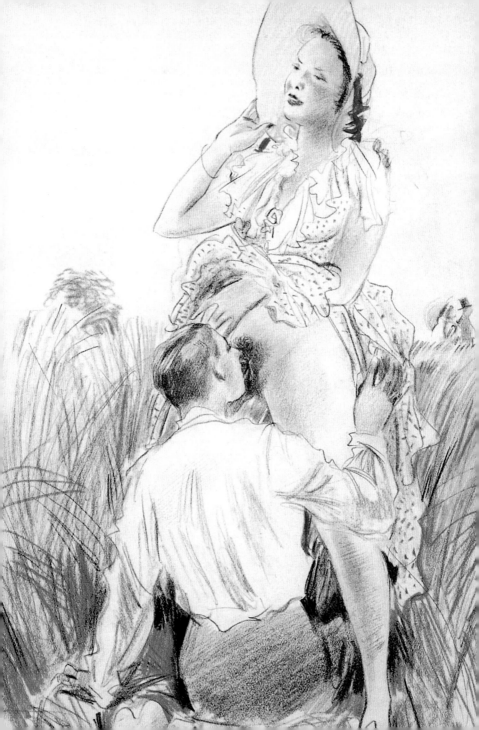

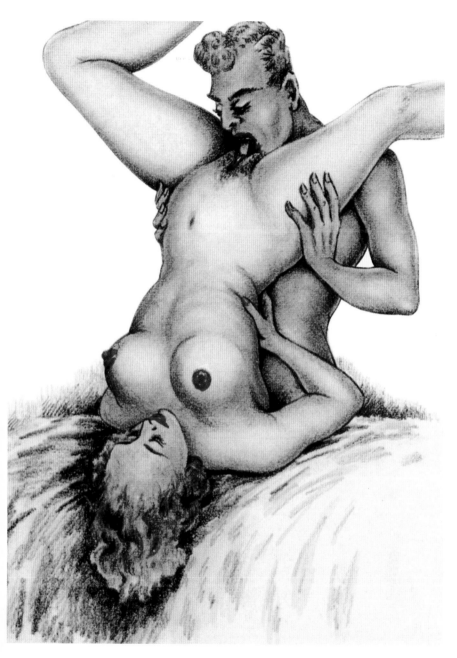

▲ *Moist Memories of a Lady of a Bygone Time.* Illustration for *Hilda*, 1950s
◄ **Rojan** Illustration for Georges Bataille's *Histoire de l'œil*, 1928 151

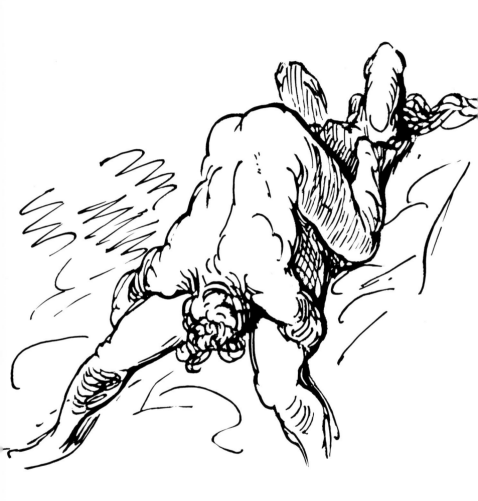

Gustave Doré *The Taste of Honey and of the Ocean*, 1873. Strasbourg, Musée de Strasbourg

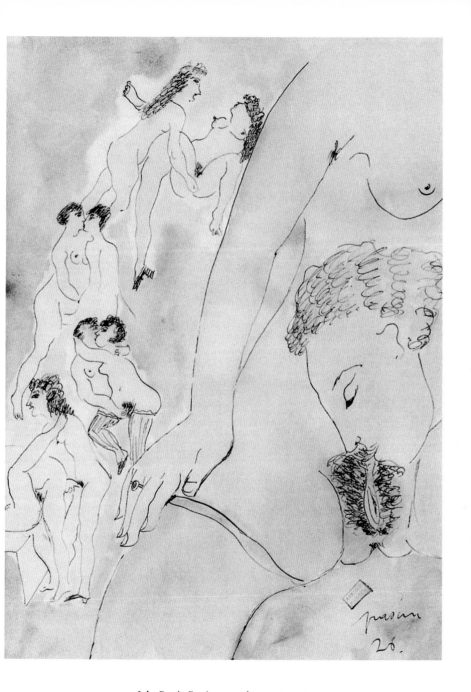

Jules Pascin Erotic watercolour, 1926–1928

Fantasies

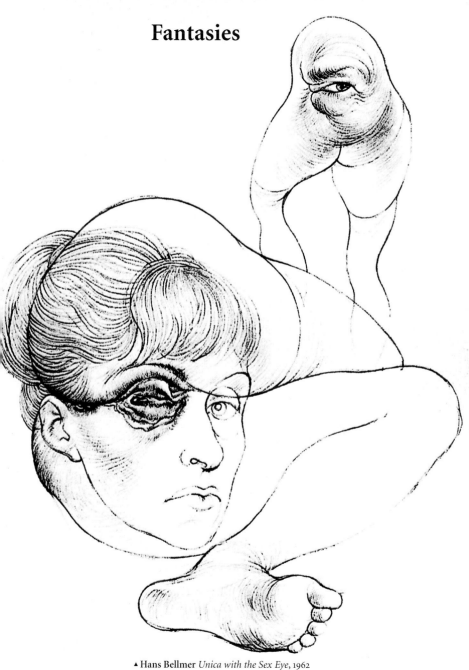

▲ Hans Bellmer *Unica with the Sex Eye*, 1962
◄ Michael Desimon *The Third Eye*. 1970s

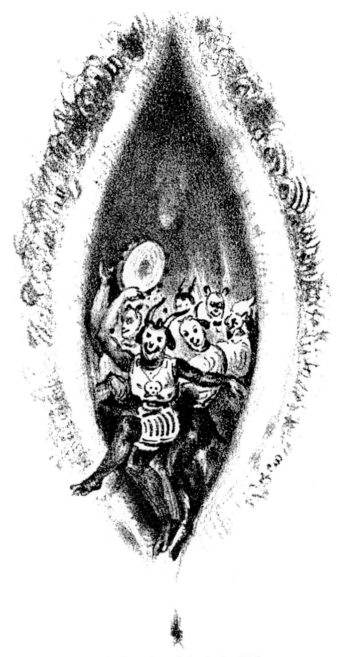

▲ **Eugène Le Poitevin** *Erotic Deviltries: Good and Evil*, 1832
▶ Attributed to **Toba Sojo,** *The Gallant Samurai*, 1140. Painting from Santo Shinwa, the Kamakura era

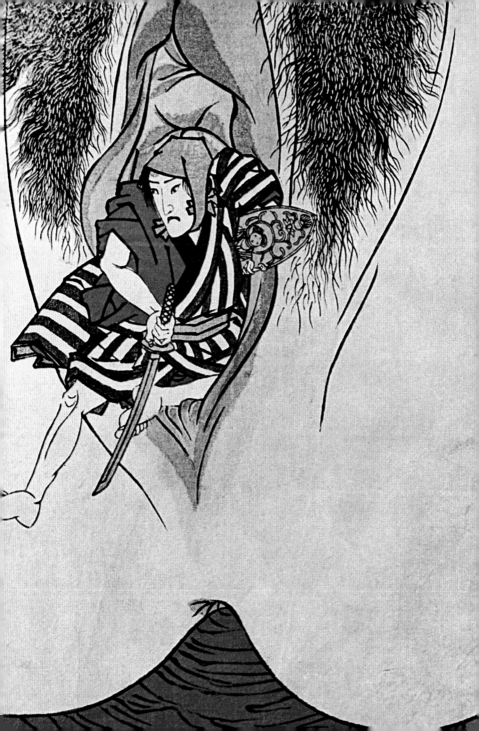

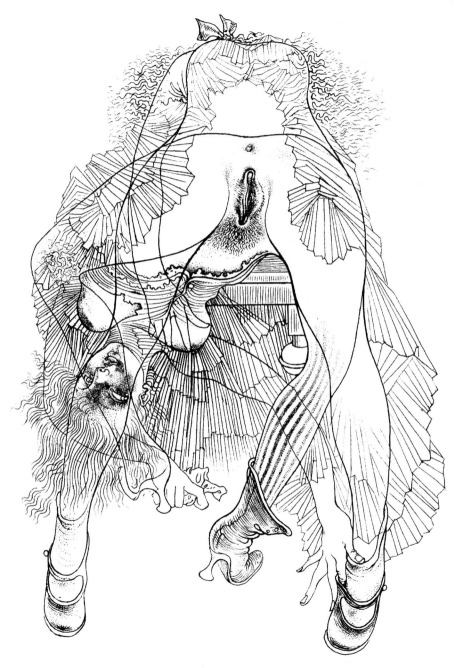

Hans Bellmer Illustration for Georges Bataille's *Histoire de l'œil*, 1947

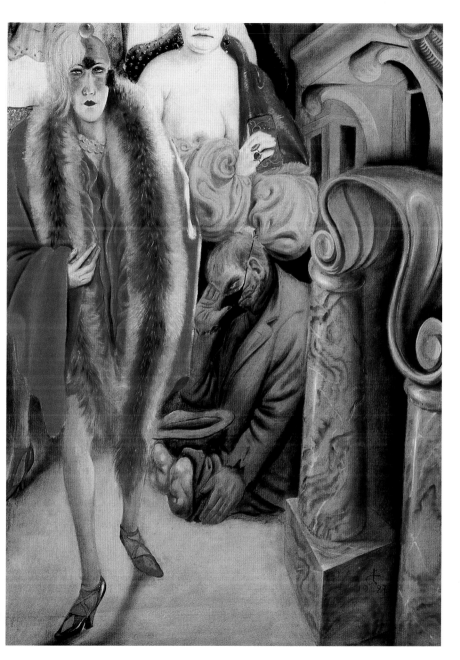

Otto Dix *Metropolis (triptych)*. Detail of the right wing, 1927/28.
Stuttgart, Galerie der Stadt Stuttgart

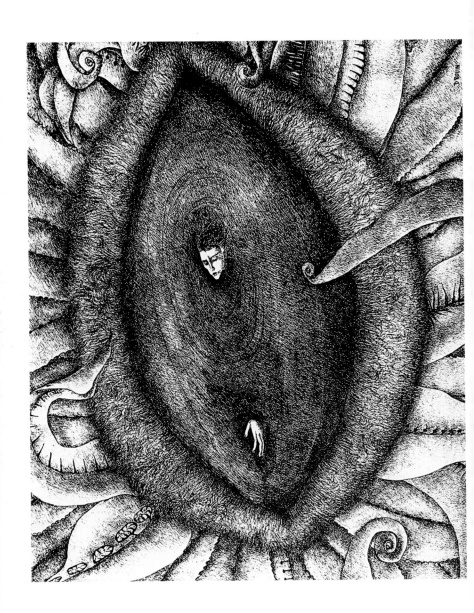

▲ Isabelle Drouin *Toi qui guéris*, 1965

► Alfred Kubin *Death Leap* (detail), 1901/02

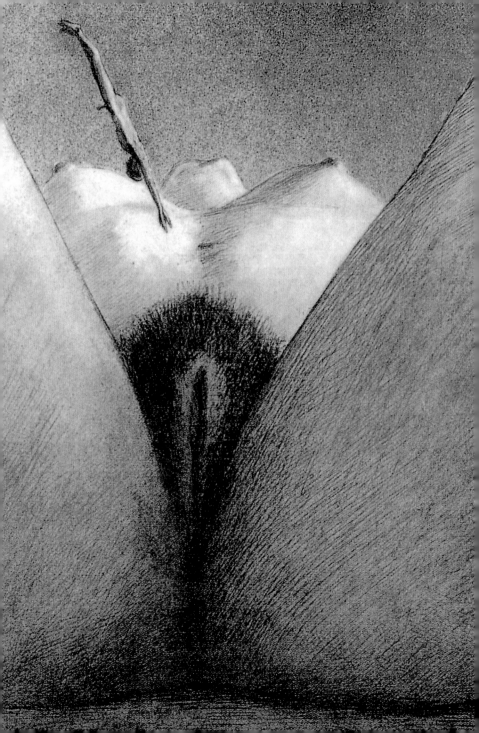

162 **Niki de Saint-Phalle** *The Figure Hon (= she)*. Installation, 1966. Stockholm, Moderna Museet

André Masson *The Open Earth*, 1938

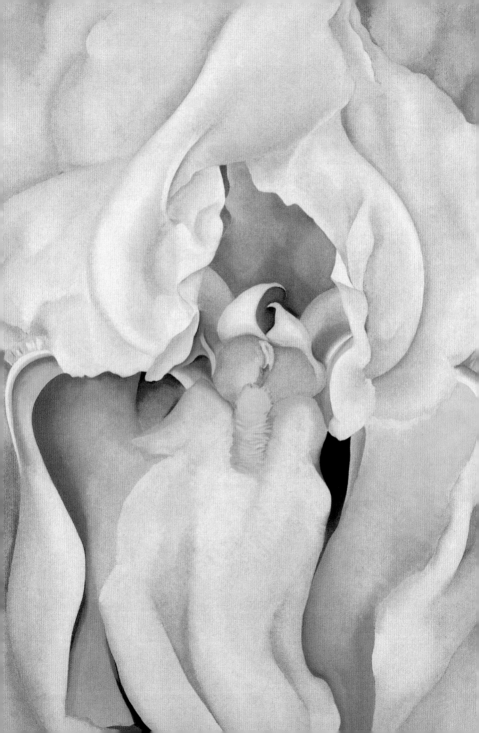

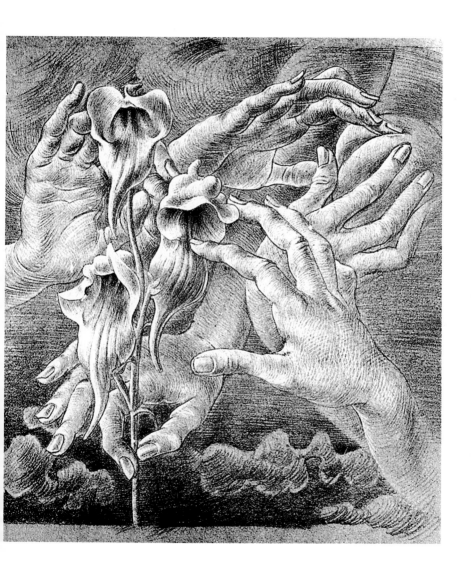

▲ Hans Bellmer *Untitled,* date unknown
◄ Georgia O'Keeffe *Light Iris,* 1924. Richmond (VA),
Virginia Museum of Fine Arts, Gift of Mr. and Mrs. Bruce C. Gottwald

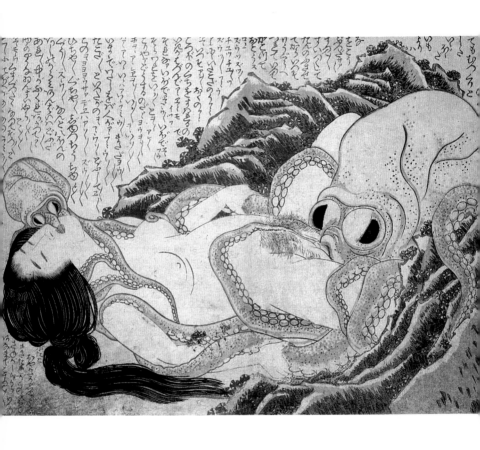

166 **Katsuskika Hokusai** *Octopus* or *Dream of the Fisherman's Wife*, c. 1814. London, The British Library

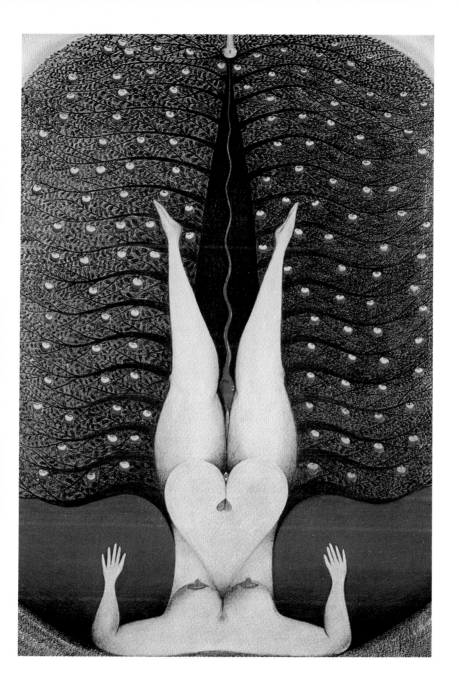

Friedrich Schröder-Sonnenstern *Die Praxis (The Practice)*, 1952

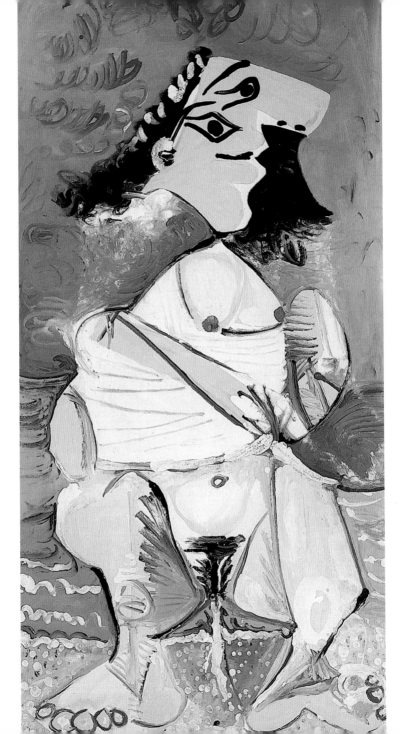

Musicals

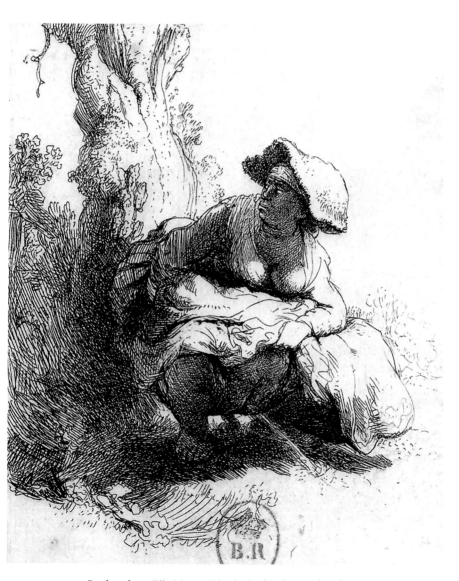

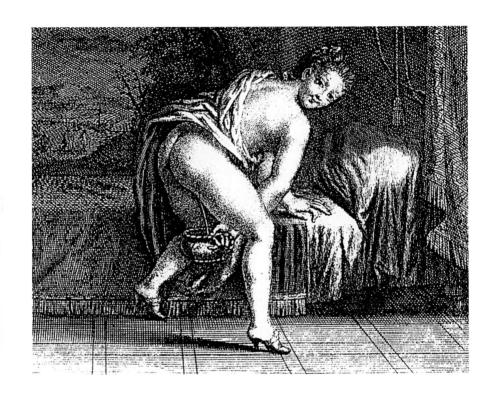

Anonymous *The Piss-Pot*, 17th c.

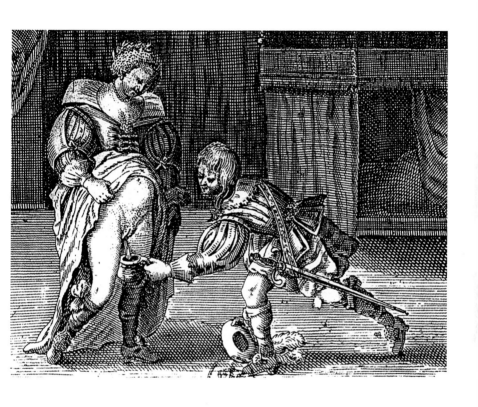

Anonymous *The Piss-Pot,* 16th c.

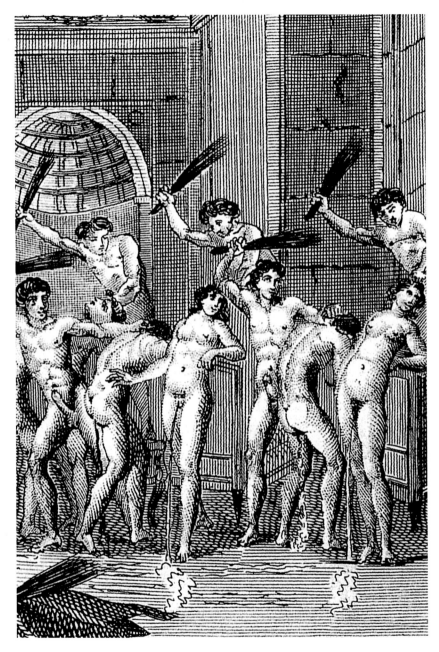

▲ Illustration from the 1797 Dutch edition of de Sade's *La Nouvelle Justine or the Misfortunes of Virtue*

▸ Peter Fendi *A toast to the Sovereign's Entrance*, c. 1835

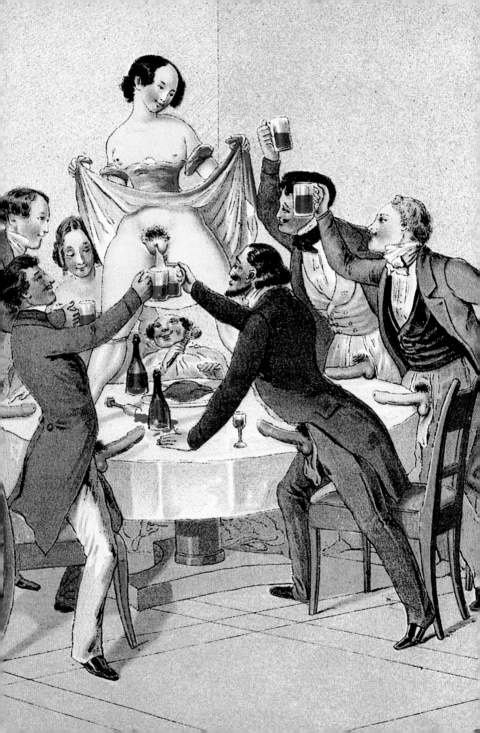

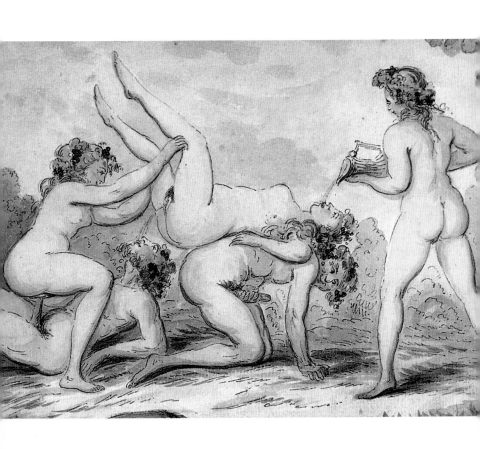

Jacques Philippe Caresme *Orgy of the Bacchantes,* 18th c.

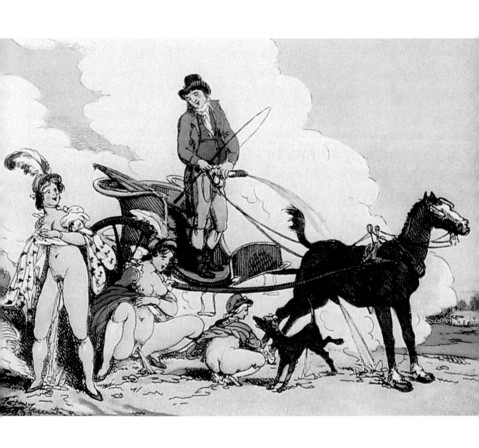

Thomas Rowlandson *The Family Outing,* c. 1808–1817

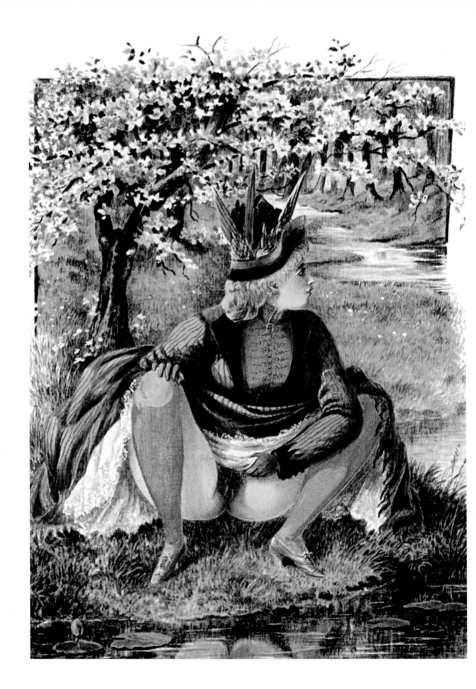

Anonymous *Pissing in the Water*. Victorian lithograph

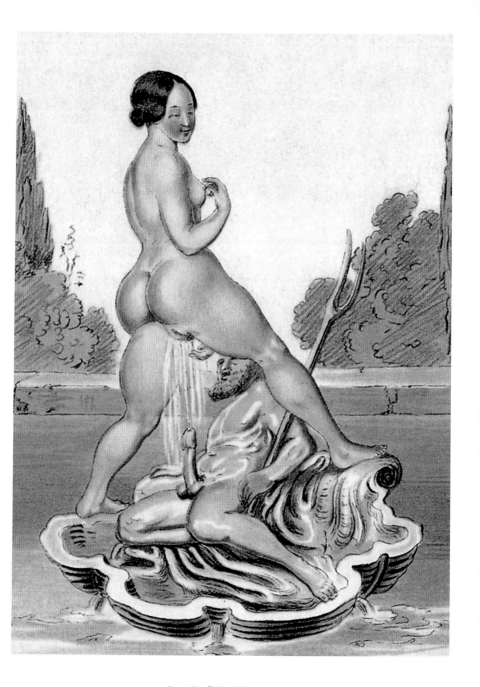

Peter Fendi *Erotic Scene*, c. 1835

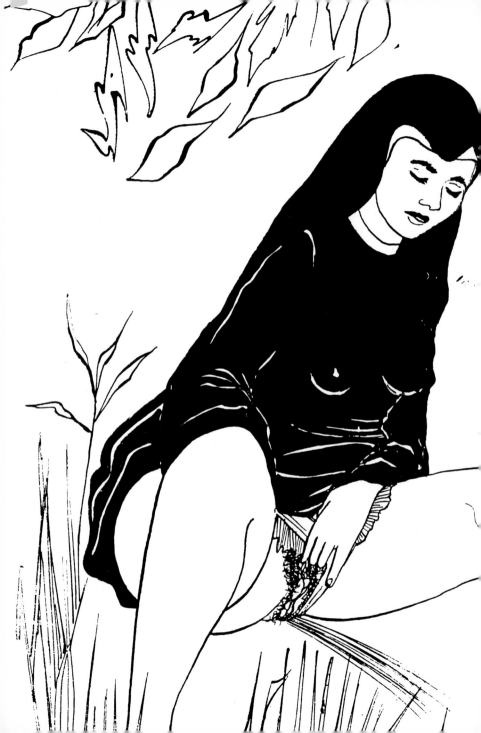

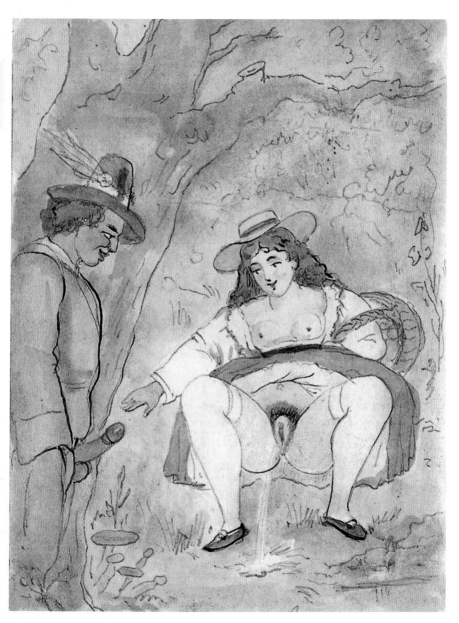

▴ **Unknown Jewish artist** *Gathering Mushrooms*, 1930s
◂ **Foujita** (?) Illustration for *The Nun*, 1940s

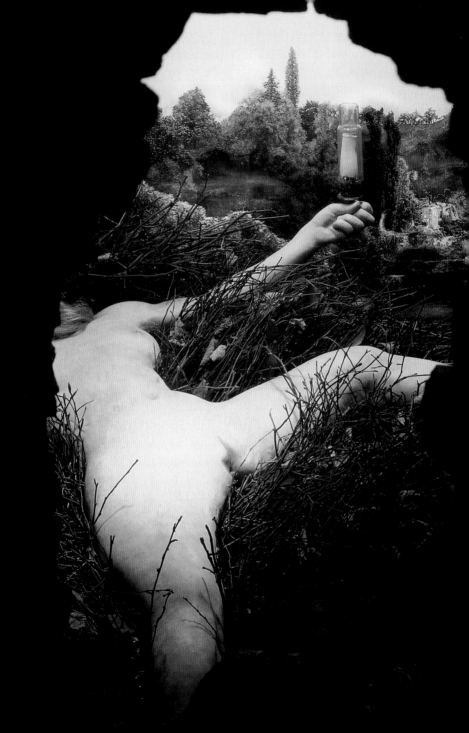

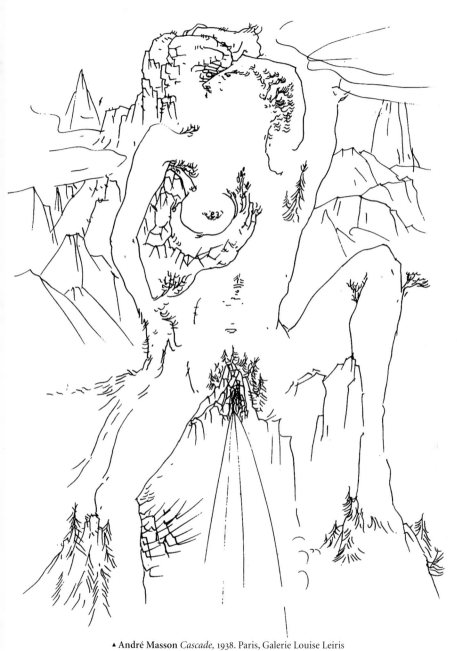

▲ **André Masson** *Cascade,* 1938. Paris, Galerie Louise Leiris
◄ **Marcel Duchamp** *Given: 1. The Waterfall … A naked virgin pissing seen through a keyhole. 1946–1966*

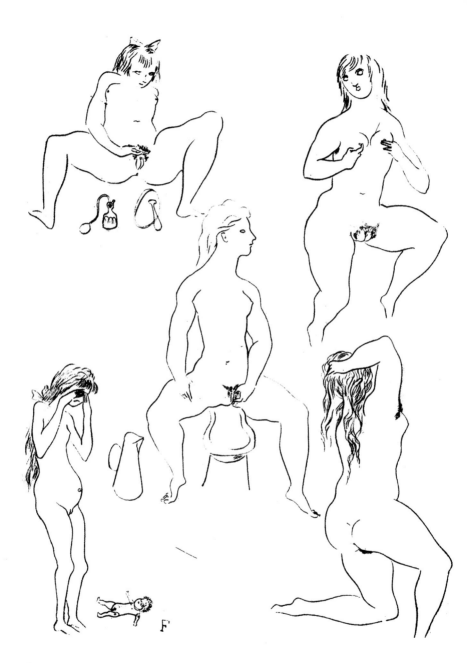

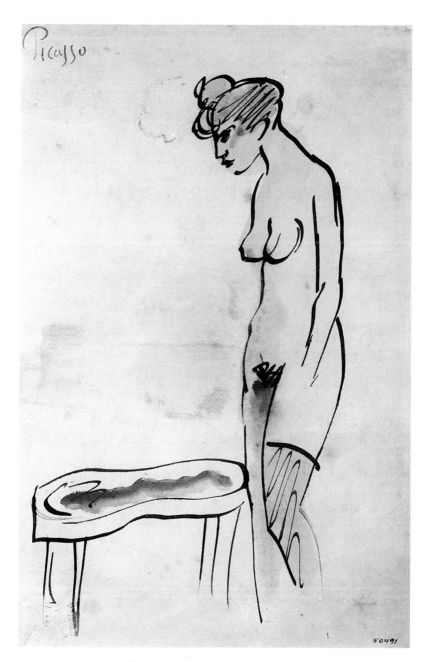

▲ **Pablo Picasso** *Female Figure* or *The Bidet*, 1902/03
◄ **Foujita (?)** *The Joys of the Toilet*, Drypoint, 1927

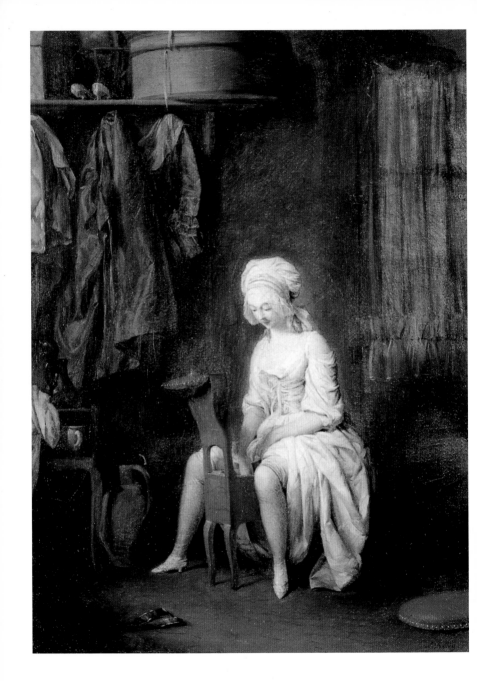

Jean-François Garneray *La toilette intime, c. 1780*

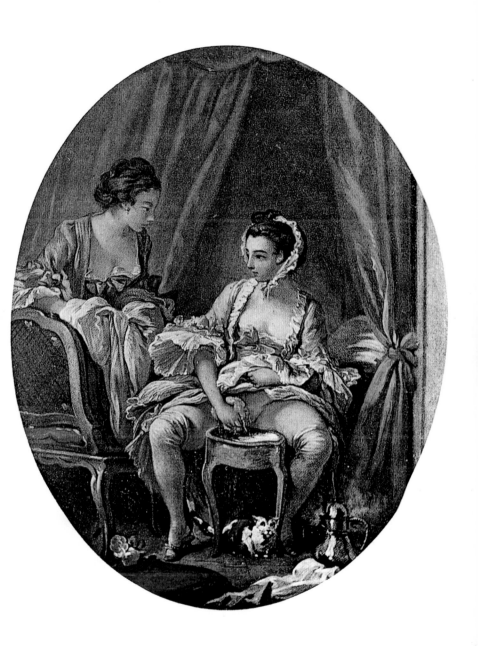

François Boucher *La Toilette intime*, 1741

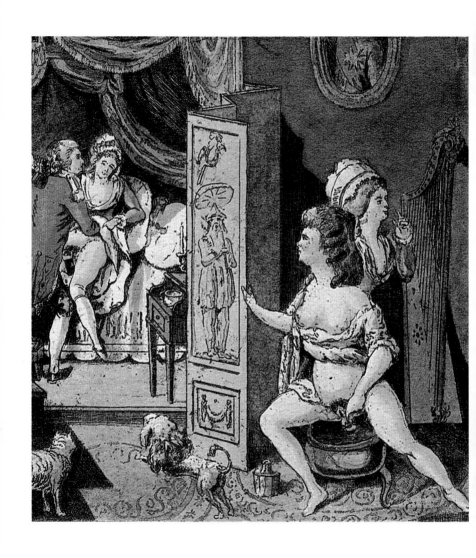

▲ **William C. B.** *Les Bigarrures. La Rouerie découverte (detail),* 1799
▸ **Anonymous** Illustration for Pierre Louÿs's *Three Daughters of Their Mother,* 1920s

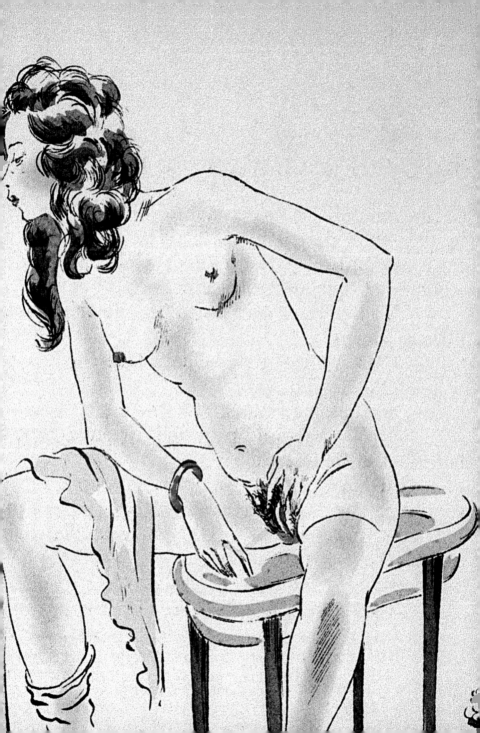

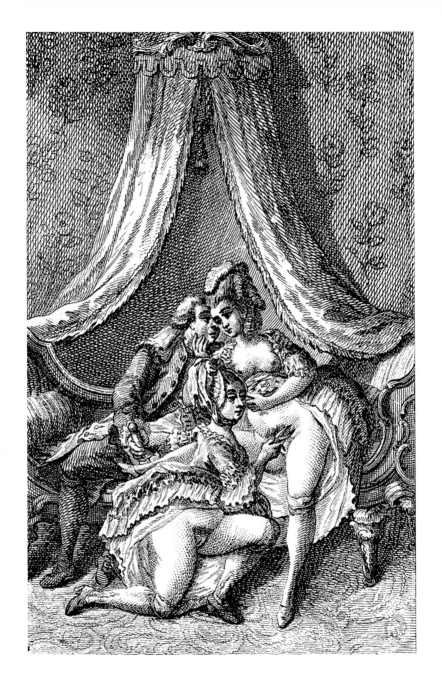

Anonymous Illustration for *Thérèse Philosophe ou Mémoires*, attributed to Diderot, c. 1748

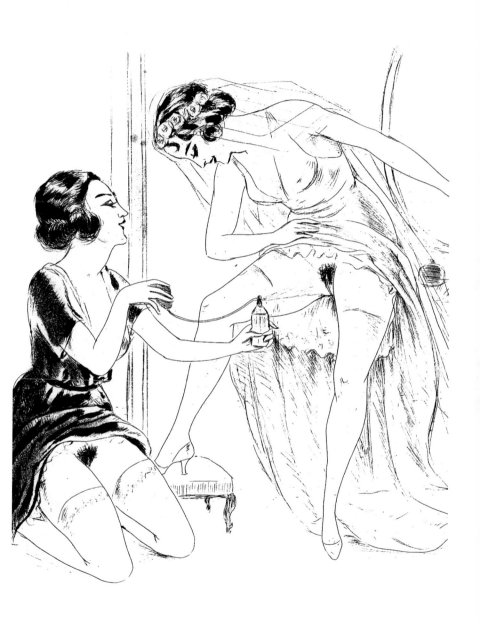

Anonymous *Le Mariage de Suzon*, c. 1925
▶▶ **Aubrey Beardsley** *The Toilet of Lampito*. Illustration for Aristophanes' *Lysistrata*, 1896 189

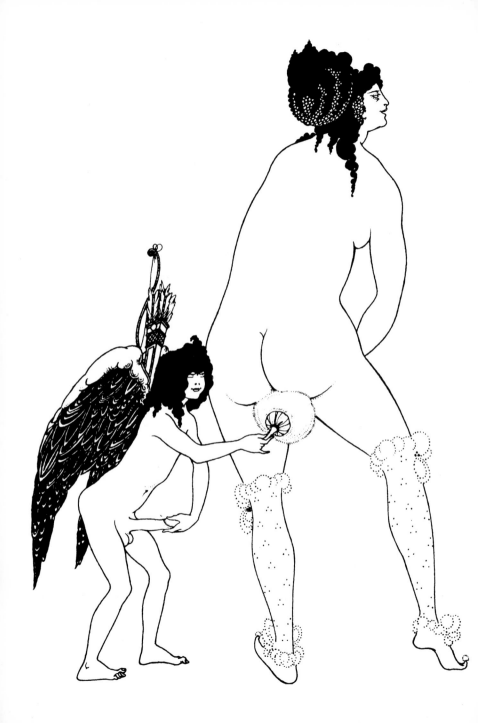

Front cover:
Albert Reiss *The Adventures of the Night,* 1967. Private collection

Back cover:
Victor Marais Milton *Young Cats.* Painting exhibited at the »Salon de Paris«, c. 1900

Frontispiece:
Albert Reiss *The Adventures of the Night,* 1967. Private collection

Acknowledgements & Credits:
The publishers wish to thank the copyright holders who greatly assisted in this
publication. Every effort was made to identify and contact individual copyright holders;
omissions are unintentional. In addition to those persons and institutions cited in the
captions, the following should also be mentioned: © Gottfried Helnwein for page 86:
»Lulu«, watercolour on cardboard, artist@helnwein.com; © The Tom of Finland
Foundation, Inc., Los Angeles for page 16; © 2003 for the illustration by Tomi
Ungerer/Courtesy of Diogenes Verlag AG, Zurich: page 127

© 2003 TASCHEN GmbH
Hohenzollernring 53, D–50672 Köln
www.taschen.com

© Demart pro Arte B.V./ VG Bild-Kunst, Bonn 2003 for the illustration by Salvador Dalí
© Succession Marcel Duchamp/ VG Bild-Kunst, Bonn 2003 for the illustration
by Marcel Duchamp
© Succession Picasso/ VG Bild-Kunst, Bonn 2003 for the illustrations by Pablo Picasso
© VG Bild-Kunst, Bonn 2003 for the illustrations by Hans Bellmer, Otto Dix, George
Grosz, Paul Klee, Alfred Kubin, André Masson, Niki de Saint Phalle, Georgia O'Keeffe,
Friedrich Schröder-Sonnenstern, Tom Wesselmann

Text and layout: Gilles Néret, Paris
Editorial coordination: Kathrin Murr, Cologne
Production: Stefan Klatte, Cologne
English translation: Chris Miller, Oxford
German translation: Bettina Blumenberg, Munich

Printed in Italy
ISBN 3-8228-2460-7

Erotoscope. Tomi Ungerer
Hardcover, 416 pp. / € 19.99
$ 29.99 / £ 14.99 / ¥ 3.900

Forbidden Erotica
The Rotenberg Collection /
Flexi-cover, 512 pp. / € 29.99
$ 39.99 / £ 19.99 / ¥ 4.900

Naked as a Jaybird
Dian Hanson / Hardcover,
264 pp. / € 29.99 / $ 39.99 /
£ 19.99 / ¥ 4.900

"These books are beautiful objects, well-designed and lucid." —*Le Monde*, Paris, on the ICONS series

" Buy them all and add some pleasure to your life."

All-American Ads 40ˢ
Ed. Jim Heimann

All-American Ads 50ˢ
Ed. Jim Heimann

Angels
Gilles Néret

Architecture Now!
Ed. Philip Jodidio

Art Now
Eds. Burkhard Riemschneider,
Uta Grosenick

Atget's Paris
Ed. Hans Christian Adam

Best of Bizarre
Ed. Eric Kroll

Bizarro Postcards
Ed. Jim Heimann

Karl Blossfeldt
Ed. Hans Christian Adam

California, Here I Come
Ed. Jim Heimann

50ˢ Cars
Ed. Jim Heimann

Chairs
Charlotte & Peter Fiell

Classic Rock Covers
Michael Ochs

Description of Egypt
Ed. Gilles Néret

Design of the 20ᵗʰ Century
Charlotte & Peter Fiell

Design for the 21ˢᵗ Century
Charlotte & Peter Fiell

Dessous
Lingerie as Erotic Weapon
Gilles Néret

Devils
Gilles Néret

Digital Beauties
Ed. Julius Wiedemann

Robert Doisneau
Ed. Jean-Claude Gautrand

Eccentric Style
Ed. Angelika Taschen

Encyclopaedia Anatomica
Museo La Specola, Florence

Erotica 17ᵗʰ–18ᵗʰ Century
From Rembrandt to Fragonard
Gilles Néret

Erotica 19ᵗʰ Century
From Courbet to Gauguin
Gilles Néret

Erotica 20ᵗʰ Century, Vol. I
From Rodin to Picasso
Gilles Néret

Erotica 20ᵗʰ Century, Vol. II
From Dalí to Crumb
Gilles Néret

Future Perfect
Ed. Jim Heimann

The Garden at Eichstätt
Basilius Besler

HR Giger
HR Giger

Indian Style
Ed. Angelika Taschen

Kitchen Kitsch
Ed. Jim Heimann

Krazy Kids' Food
Eds. Steve Roden,
Dan Goodsell

London Style
Ed. Angelika Taschen

Male Nudes
David Leddick

Man Ray
Ed. Manfred Heiting

Mexicana
Ed. Jim Heimann

Native Americans
Edward S. Curtis

New York Style
Ed. Angelika Taschen

**Extra/Ordinary Objects,
Vol. I**
Ed. Colors Magazine

15ᵗʰ Century Paintings
Rose-Marie and Rainer Hagen

16ᵗʰ Century Paintings
Rose-Marie and Rainer Hagen

Paris-Hollywood
Serge Jacques
Ed. Gilles Néret

Penguin
Frans Lanting

Photo Icons, Vol. I
Hans-Michael Koetzle

Photo Icons, Vol. II
Hans-Michael Koetzle

20ᵗʰ Century Photography
Museum Ludwig Cologne

Pin-Ups
Ed. Burkhard Riemschneider

Giovanni Battista Piranesi
Luigi Ficacci

Provence Style
Ed. Angelika Taschen

Pussy Cats
Gilles Néret

Redouté's Roses
Pierre-Joseph Redouté

Robots and Spaceships
Ed. Teruhisa Kitahara

Seaside Style
Ed. Angelika Taschen

Seba: Natural Curiosities
I. Müsch, R. Willmann, J. Rust

See the World
Ed. Jim Heimann

Eric Stanton
Reunion in Ropes & Other
Stories
Ed. Burkhard Riemschneider

Eric Stanton
She Dominates All & Other
Stories
Ed. Burkhard Riemschneider

Tattoos
Ed. Henk Schiffmacher

Tuscany Style
Ed. Angelika Taschen

Edward Weston
Ed. Manfred Heiting

ICONS